IMAGES
of America

YPSILANTI

A HISTORY IN PICTURES

IMAGES
of America

YPSILANTI

A HISTORY IN PICTURES

James Thomas Mann

ARCADIA

Published by Arcadia Publishing,
an imprint of Tempus Publishing, Inc.
3047 N. Lincoln Ave., Suite 410
Chicago, IL 60657

Printed in Great Britain.

Library of Congress Catalog Card Number: 2002106590

For all general information contact Arcadia Publishing at:
Telephone 843-853-2070
Fax 843-853-0044
E-Mail sales@arcadiapublishing.com

For customer service and orders:
Toll-Free 1-888-313-2665

Visit us on the internet at http://www.arcadiapublishing.com

CONTENTS

Introduction 7

1. The Early Years: 1823–1849 9

2. The 1850s 23

3. The 1860s 39

4. The 1870s 51

5. The 1880s 67

6. The 1890s 95

INTRODUCTION

Ypsilanti is a small city with a remarkable history. Since it was founded in 1823, Ypsilanti has experienced developments in education, industry, and social activity. It began as a pioneer community on the edge of the frontier, and has grown into a modern city with an exciting future.

The site that is now Ypsilanti was the point where an old Indian trail crossed the Huron River. Three Frenchmen—Gabriel Godfroy, Francois Pepin, and Romaine LaChambre—founded a trading post there in 1809. Known as "Godfroy's on the Pottawatomie Trail," it was the first permanent structure in what is now Washtenaw County. The post stood on the bluff overlooking the Huron River, on what is now Huron Street, just south of Michigan Avenue. This was most likely a simple structure, a block house made of logs enclosed by a palisade. There Godfroy and his partners conducted business with the Native Americans who camped in the area. They traded gunpowder and other items for the fur of beaver and other animals.

"In 1811," wrote Harvey C. Colburn in *The Story of Ypsilanti*, published in 1923, "the three Frenchmen took up large tracts of land in the vicinity, which were later known as the French Claims. The northern boundary of the claims, beginning at the river, followed the line of the present Forest Avenue and so on in a south-westerly direction for about two miles. The line then turned south-easterly at right angles, running for two miles, and then turned again to a point of intersection with the river. The claims thus included an area of approximately two square miles, or about 2,500 acres, with the river as its eastern boundary. This region was divided into four practically equal sections running westerly from the river, each half a mile wide and two miles long. The northern region belonged LaChambre, the next to Godfroy, the next to Godfroy's children and the southern region belonged to Pepin." The deeds were signed by President James Madison. The boundaries of the French Claims still appear on maps of Ypsilanti today.

The Native Americans, feeling the encroachment of the Americans, moved west, and by 1820, the traders had followed them. The trading post now stood empty, and was allowed to fall into ruin.

In 1825, the territorial government of Michigan commissioned Orange Risdon to survey a road linking Detroit and Chicago. "He found his task made easy," wrote Colburn, "by the existence of the old Indian trail from Detroit to the Huron Valley. Following this route, he avoided such obstructions as bluffs and swamps and crossed the streams at the most advantageous points."

The surveyed route passed just south of the old trading post. For this reason three enterprising men—Federal Judge Augustus Brevoot Woodward of Detroit, John Stewart, and William H.

Harwood—purchased the French Claims from the families of Godfroy, Pepin and LaChambre, and platted a village there as soon as the road was surveyed. It was Judge Woodward, a lover of all things classical, who named the village Ypsilanti. Other names were considered, including "Waterville," in recognition of the power that the Huron River provided to local mills. Some suggested the names of the towns in New York State from which they had come, a common practice at the time, but Judge Woodward stood firm. He was the lead investor in the venture, and his was the dominant personality. His choice may have been a wise one, as the name Ypsilanti remains distinct from the names of other communities.

Soon settlers purchased their lots, built their homes and started businesses. Their lives were difficult. They faced hardships, suffered failures, and eventually enjoyed successes. Over time, they built a new community.

Throughout the years that followed, the people of Ypsilanti would see many changes. Their town has been the home of interesting people and the site of colorful events. The railroad first came through Ypsilanti in 1838, and had a major effect on the city. No longer a frontier community, Ypsilanti was connected to the world. Now the people of Ypsilanti could ship their goods to distant markets and have the latest in modern conveniences delivered almost to their door.

Ypsilanti was also a major station in a different type of railroad, the Underground Railroad, and many prominent citizens were proud to take part. Dr. Helen McAndrew was the first female physician in Washtenaw County. She treated her patients from her octagonal house on South River Street. Dr. McAndrew and her husband, William, were active in the Underground Railroad and later in the Temperance movement. Ypsilanti became known around the world for its mineral water, the Michigan Central Gardens, and underwear. As a center of education, it was home to the Normal School which is now Eastern Michigan University. The story of Ypsilanti is one well worth telling.

I wish to express my gratitude to the Ypsilanti Historical Society, the Archives of Eastern Michigan University, and especially to Maria Davis and Rosina Tammany for helping me tell the story of Ypsilanti in pictures.

One

THE EARLY YEARS

1823–1849

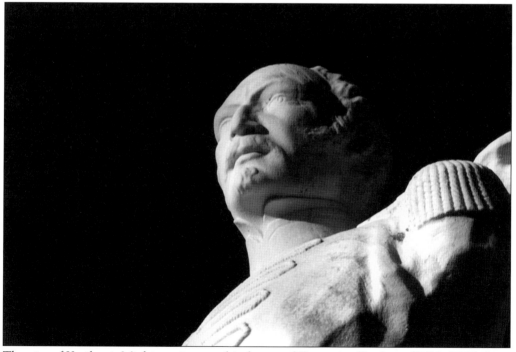

The city of Ypsilanti, Michigan, is named in honor of Demetrius Ypsilanti (1793–1832), hero of the War of Greek Independence. For 3 days Demetrius and his command of 300 men held the Citadel of Argos against an army of 30,000 Turks. Their provisions exhausted, Demetrius and his men escaped without the loss of a single man.

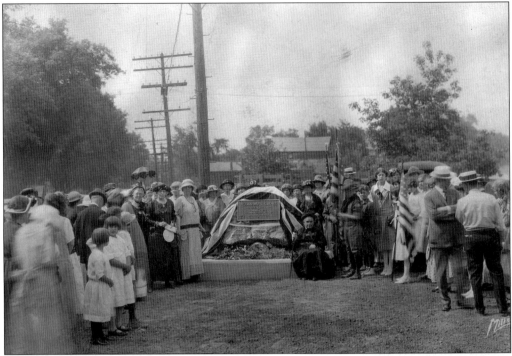

Washtenaw County was Woodruff's Grove, founded in 1823 about a mile south of Ypsilanti. It was little more than a collection of small farms set along the Huron River. This picture shows the dedication of the monument at Prospect and Grove Road, in July of 1923.

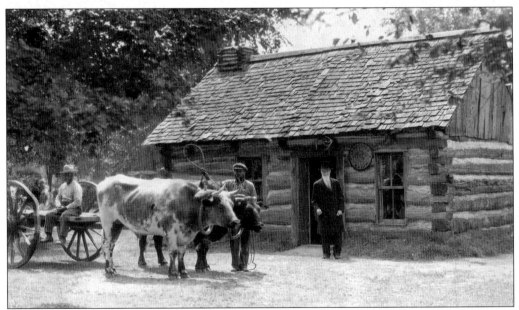

The settlers at Woodruff's Grove and early Ypsilanti lived in log cabins. The community failed in 1825, when the road from Detroit to Chicago was surveyed a mile to the north. The cabin pictured here was built as part of the centennial celebration in July of 1923. Standing near the door of the cabin is Seth Reed, who was celebrating his own centennial that year.

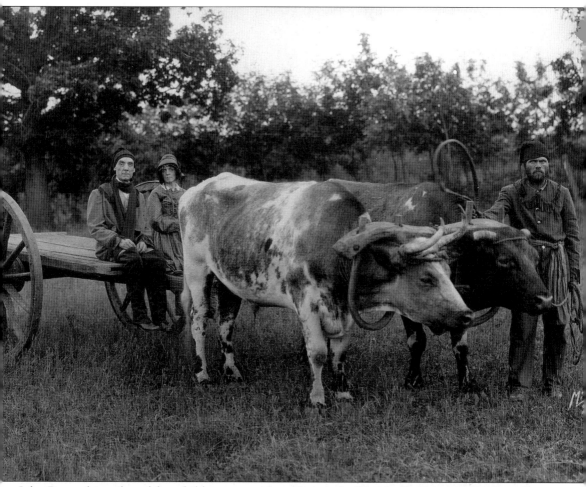

John Bryan, his wife and five children set out from Detroit for Woodruff's Grove in October of 1823 with a team of oxen. They arrived at Woodruff's Grove on October 23, 1823. It had taken them four days to make the trip, because they had to clear the road for the team. The Bryan family was the first to reach Woodruff's Grove by way of the Sauk Trail, now Michigan Avenue. Those who had come before them had come on barges on the Huron River. The team pictured here were at the centennial celebration of 1923.

At first, the road from Detroit to Chicago was little more than a path between the trees. Improvements were made, and by 1830, travel by stagecoach was possible. Three stage lines served Ypsilanti by 1832. The trip from Detroit to Ypsilanti was recreated as part of the centennial celebration in 1923.

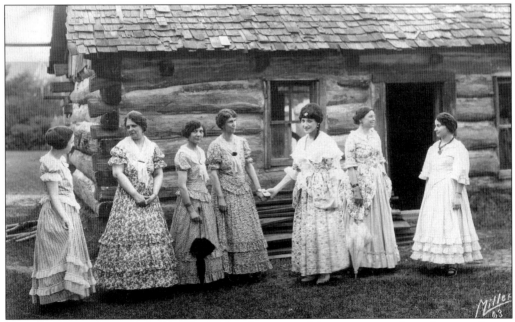

Women have played a major role in the development of the community from the start. It was the women who made Woodruff's Grove, and later Ypsilanti, a fit place for families to live. They accomplished this with a civilizing influence, their skill in the "domestic arts," and by teaching school. The women pictured here took part in the centennial celebration of 1923.

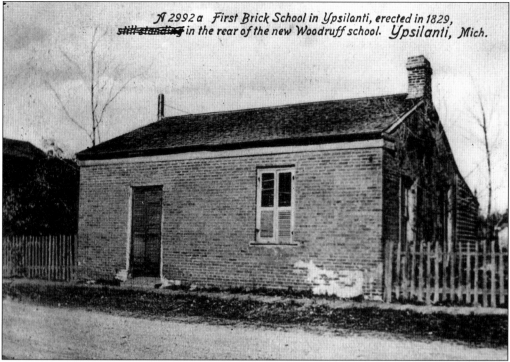

A 2992 a First Brick School in Ypsilanti, erected in 1829, ~~still standing~~ in the rear of the new Woodruff school. Ypsilanti, Mich.

From the earliest day, education has played an important role in the history of Ypsilanti. Mothers at Woodruff's Grove would teach Sunday School in one of the log cabins. The first brick schoolhouse in Ypsilanti was built in 1829. Charles M. Woodruff later used the building as his residence. The building has since been demolished.

The first public, or district, school on the west side of the river is believed to have been taught by Channcey Joslyn. This was a one-room school house, known as the "White School House," which remained in use until 1848. A section of the old school is still standing, as part of a private home at 119 North Washington Street.

Arden H. Ballard (1799–1867) had settled in Ypsilanti by 1828. He was a builder who may have built the Ladies Literary Clubhouse, as well as several other homes in and near the city. It was Ballard who added the Roman Doric columns to his home at 125 North Huron in 1845. Ballard lived in the house from 1840 until his death. Ballard was President of the Village of Ypsilanti from 1847 to 1857, and was the second mayor of Ypsilanti during the years 1859 and 1860.

The Presbyterian Church at Ypsilanti formed in 1829 with 12 members. The congregation was jointly established by the Congregational and Presbyterian denominations, and was organized as the Congregational Society of Ypsilanti on October 4, 1830. The congregation voted to adopt the Presbyterian form of government in 1832. That same year plans were made for a church building, which was built on Person Street between Adams and Hamilton. The church was dedicated on November 23, 1836.

Mark Norris (1796–1862) was one of Ypsilanti's earliest settlers, coming to the village in 1828. An enterprising, energetic man, he probably did more for the development of Ypsilanti than any other single person. He owned the Ypsilanti Flouring Mill on Cross Street, a carding company, and a dry goods store. Norris was one of the first trustees of the village of Ypsilanti and was postmaster from 1829 to 1837. It was Norris who arranged for the railroad to build the depot at Cross and River, giving birth to what is now the Depot Town section of the city.

When Roccena Norris (1798–1876) first glimpsed her new home of Ypsilanti from the high bluff that is now Highland Cemetery, she broke down and wept, perhaps at the realization of the hard life that waited. As the family prospered, they moved into a lovely home on River Street, now 213 River Street. There Roccena tended her garden. Because of the Norris' fancy for entertaining visiting clergymen, the house was sometimes called "The Ministers' Hotel."

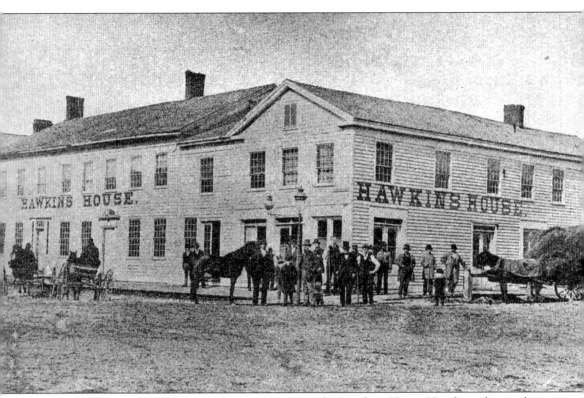

Weary travelers could always find a place to stay at the Hawkins House Hotel, on the northwest corner of Michigan and Washington Streets. It began as a log building constructed by John Stewart about 1827, and was used as a trading house by his father-in-law. In about 1830 the property passed into the hands of a man named Foster. He built a two story frame house west of the log building, and this became the hotel of the village. The property was deeded to Abiel Hawkins in 1834, and he made further additions to the building's structure. In 1846, Abiel Hawkins deeded the property to his son Walter, who continued in the hotel business until 1879. That year the old hotel was removed, and a new brick hotel was built just west of the original site.

According to local tales, this was the first post office building in Ypsilanti, just north of 214 South Grove Street. The building originally stood on Michigan Avenue, then called Congress Street, next to the Hawkins House Hotel. It was used as a millinery shop called "The Colonial Building." John McCready used a wheel arrangement with papers and letters arranged alphabetically. The building was moved to South Grove Street, where it was then used as a residence. Over time it was allowed to fall into disrepair, and it burned in the early 1920s .

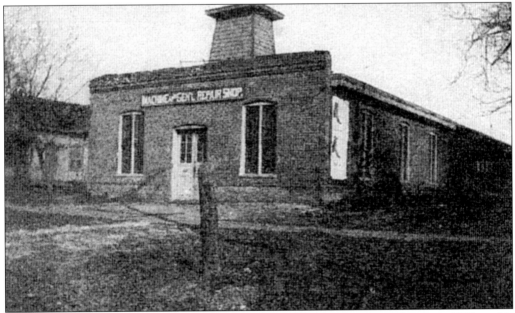

The Methodist community began building a small brick chapel on River Street in 1831, and it was completed by 1837. The Methodists continued to meet here until 1843. That year, the Baptists began meeting in the chapel, and used it as a place of worship until 1847. Since that time, the building has been put to many uses. The Worden Brothers manufactured whip sockets here in the 1870s and 1880s. Part of the building still stands at 110 North River Street.

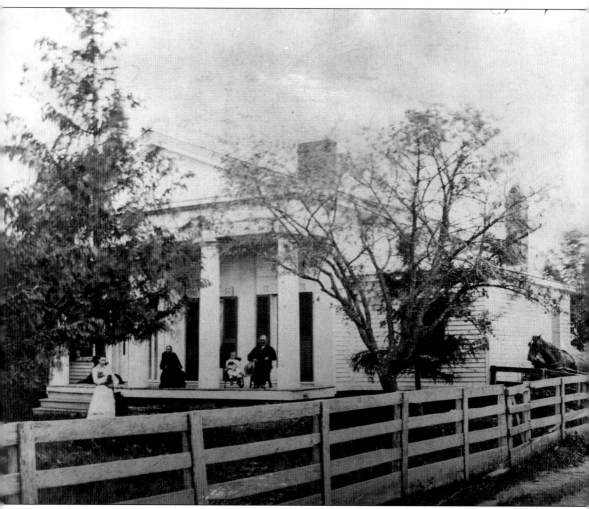

The Foerster House at 428 South Grove, was possibly one of the oldest houses in Ypsilanti. It is not certain when the eleven-room structure was built, but it may have been as early as 1836, when Arden H. Ballard paid a mortgage of $2,500 for the property. The house then became part of a large farm owned by Addison Fletcher from 1865 through 1895. That year the house was sold to L.Z. Foerster, who owned the Grove Brewery and Bottling Company. The building was known as The Foerster House for years to come. It was moved from its original location during World War II, upon construction of I–94. The house was then demolished in 1962, to make room for a gas station.

In 1837, the same year Michigan became a state, The Ark was built on the southeast corner of Pearl and Washington. Although it remained a local landmark for many years, it was always something of an eyesore, and few were sorry to see it demolished in 1912.

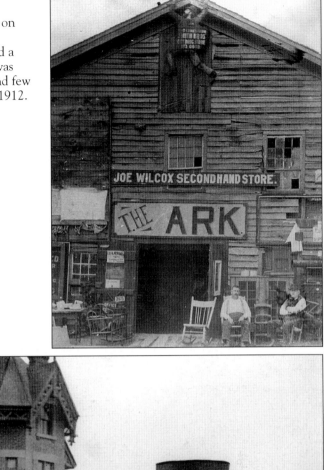

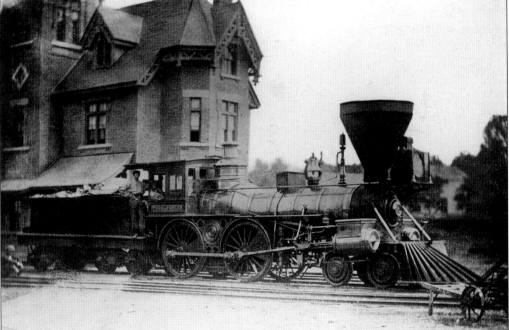

As the first train arrived on February 2, 1838, Ypsilanti ceased to be an isolated frontier community. To celebrate, a delegation of dignitaries, including the governor, rode the train from Detroit. They spent the day in Ypsilanti giving speeches and enjoying food and drink. On the return trip, the train broke down in Dearborn, and could not be repaired. A team of oxen pulled the train the rest of the way, but the men had to walk, singing songs as they did.

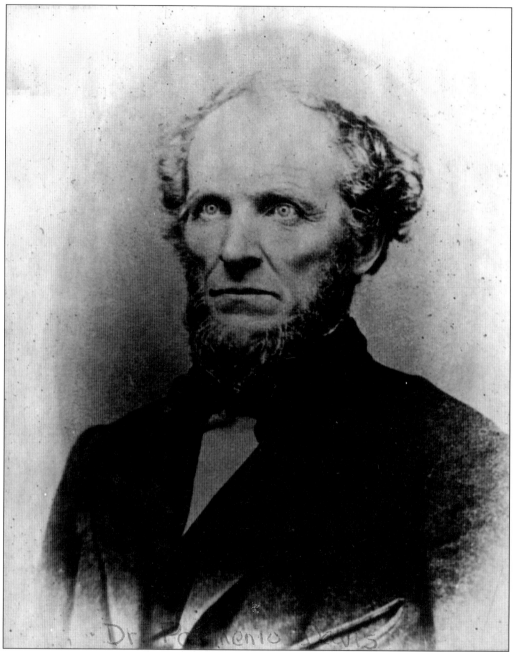

Parmenio Davis, M.D. (1816–1883) came to Ypsilanti in 1840, after graduating from Western Medical College in Willoughby, Ohio. He traveled out on horseback in all kinds of weather to tend to the sick and suffering. Dr. Davis carried on his medical practice while serving as Alderman of the 5th Ward in 1858. He was then elected the fourth Mayor of Ypsilanti, a position he held for four terms.

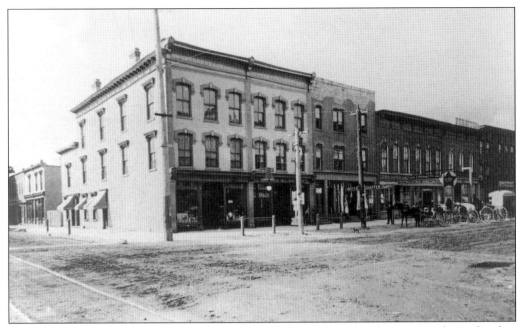

On the southwest corner of Michigan and Washington Streets, what was perhaps the first pretentious building in Ypsilanti was built by Solomon Y. Larzelere in the 1840s. Made of brick and rising three stories high, it was known for many years as the Larzelere Block. Later it was purchased by S.B. Morse, so it became known as the Morse Block. Today the building still stands, and has changed very little with time. This photograph was most likely taken in the 1890s.

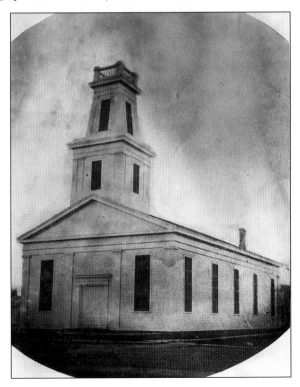

By 1843, the Methodists of Ypsilanti realized that they needed a new church. The original church on River Street was no longer adequate for their needs and the foundations were considered unsafe. The congregation had experienced serious poverty, and believed the task of building a new church was beyond their means. Then Dr. T.M. Town assumed responsibility for the new church, giving land and advancing money. Dr. Town was reimbursed by the sale and rental of pews. The new church at Washington and Washtenaw was dedicated that same year.

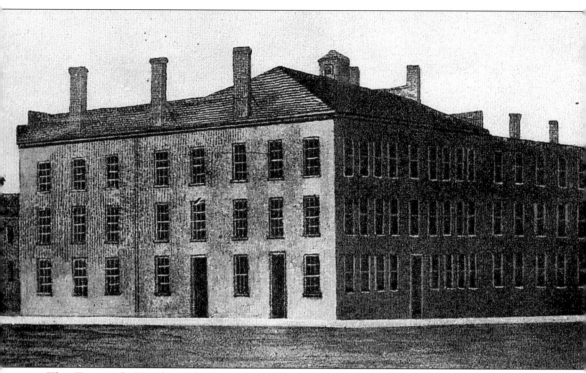

The Tecumseh Hotel was built to house the patrons of a railroad that never came about. Charles Woodruff moved his academic school into a portion of the hotel in 1844. He continued here until 1848, when the building was purchased by a company headed by the Rev. L.H. Moore, pastor of the Baptist church. Rev. Moore began operating a private school in the building, called The Ypsilanti Seminary. The school board purchased the building from Rev. Moore for $2,400 in 1849. This may have been the first "graded school" in Michigan. The building was destroyed by fire on the morning of Sunday, March 29, 1857.

Two
THE 1850s

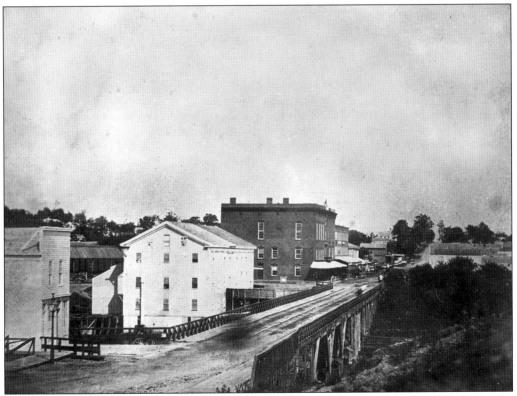

Pictured is the view looking east on Cross Street, in about 1859. The building at the left is the first City Hall and jail. The city council met in a chamber on the first floor, and the jail was in the basement. The building in the middle is the City Mill, a flour mill dating back to the early days of the city. Just past the mill is the Follett House Hotel.

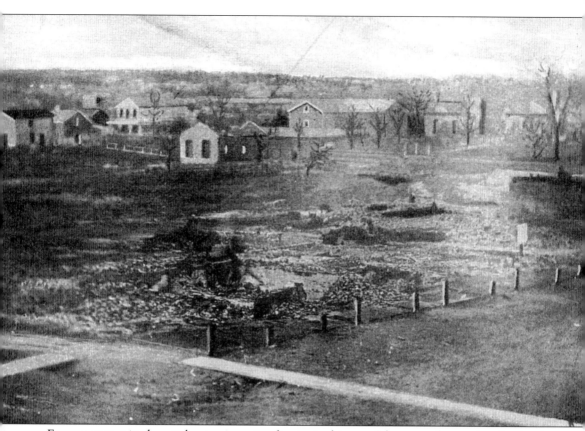

Every community has at least one major fire in its history. The most destructive fire in the history of Ypsilanti began at about 1:00 a.m. on Tuesday, March 28, 1851, when flames were seen in J. Cady's store on the corner of Michigan and Washington. The fire engulfed almost everything on the north side of Michigan Avenue, from Washington Street to Pearl. It spread across Huron Street, burning everything in its path to the river. Even as the embers still glowed amid the charred ruins, property owners drew up plans for new and more substantial buildings.

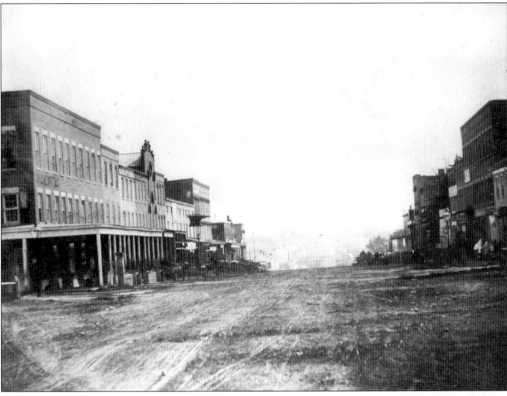

Pictured is the view on Michigan Avenue, then called Congress Street, looking west, in about 1859. This was the first business district in the city, because it lined the road linking Detroit and Chicago. The first buildings were made of wood, and were destroyed in the fire of 1851. These were replaced with buildings made of brick, many of which are still standing.

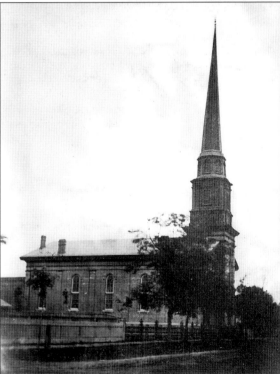

The First Presbyterian Church building, at Washington and Emmet, was dedicated on September 23, 1857. Construction had taken two years, and was completed at a cost of $12,000. When built, the church had a single spire, which proved to be unsafe and had to be removed.

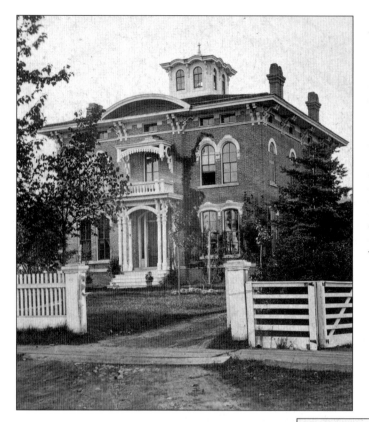

John Sedqwick Jenness established a wholesale grocery store in Detroit in the 1830s, which became one the leading commercial concerns of the city. Jenness made Ypsilanti his home in 1858, building this commodious brick residence at 324 West Forest that same year. He continued to conduct business in Detroit, making the daily trip by train until his retirement. The house remained in the Jenness family until 1930.

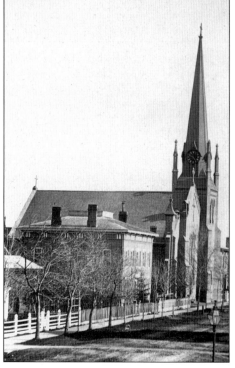

St. Luke's Episcopal Church was dedicated June 28, 1858. Today St. Luke's is the oldest church building in Ypsilanti, and one of the oldest Gothic Revival churches in the state. Numerous other churches would later be built in Michigan using the same plan, a fact that illustrates the importance of Ypsilanti during the mid-19th century. When constructed, the church featured a 128-foot-tall spire. The spire was removed in 1971, because of concerns over its structural integrity.

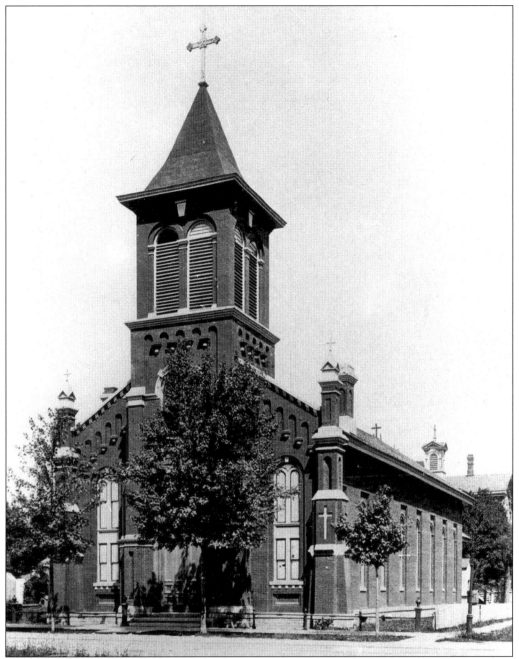

St. John the Baptist Catholic Church was founded by Irish Catholic immigrants, who began to settle in the area by the late 1820s. A small wood frame chapel was built on the site of the present church in 1839. In 1845, a 24-by-16-foot church was erected on the site. The poverty of the parish was such that blankets had to be hung over the windows in winter to keep the wind from blowing out the candles. By 1855, the parish was calling for a new church. The new church was finished by Christmas of 1858, but had no doors, no pews, and the entrance was formed by an inclined plank. The church also had no debt. The first service was the wedding of Mr. and Mrs. John Kennedy.

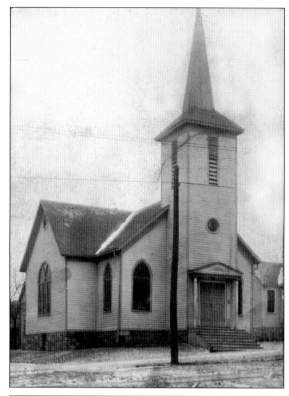

Emmanuel Lutheran congregation was organized in 1859 by 16 members, with the aid of the Rev. Frederick Schmid. Within a year of its founding, the small congregation had built a wooden church at Michigan and Grove on land donated by Mark Norris. The church remained in use until 1923. Initially, Emmanuel Lutheran was a German-language church, and English was not used until 1912.

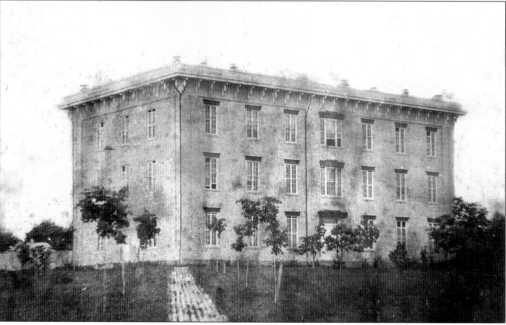

The first Normal School building was dedicated on October 5, 1852. This was the first Normal School west of the Alleghenies, and the sixth in the nation. A teachers' college was called a Normal School, because the mission of the institution was to bring about the "normalization" of standards. The building was destroyed by fire on October 28, 1859.

Adonijah Strong Welch (1821–1889) was appointed Principal of the Michigan State Normal School in the fall of 1852, becoming the first head of the institution. He was largely instrumental in giving form and character to the institution, but was more interested in maintaining strict discipline than in promoting excellence in teaching. His idea of a school was one which maintained a condition of perfect system and order. He resigned in 1865, due to ill health. Welch represented Florida in the U.S. Senate, and was the first President of Iowa State Agricultural College at Ames.

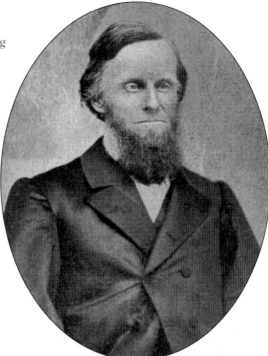

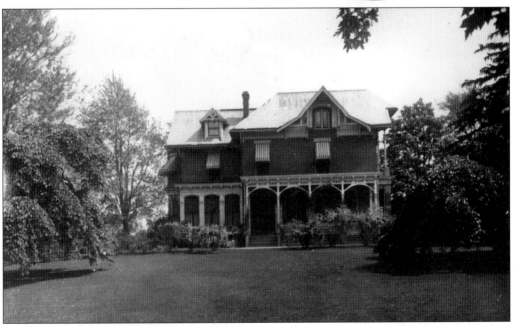

Adonijah S. Welch lived in this house, just north of the campus, until August of 1865. Then he sold the house to Samuel Post, a local merchant, for $9,550. Post lived in the house until 1893, when he rented the house to Richard Boone, the first President of the Michigan State Normal College. Boone lived there with his family until 1899, when the State Board of Education removed him from office. The house, which was the first official residence of the Normal College president, was demolished in 1938, and the site is now occupied by King Hall.

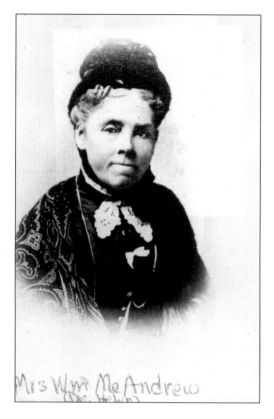

Mrs Wm McAndrew (Dr. Helen)

Helen Walker McAndrew (1826–1906), a native of Scotland, moved to Ypsilanti with her husband, William, in 1850. There she found she had a talent for nursing, and decided to become a doctor. Leaving her husband and young son behind, she enrolled at the Trail Hydropathic Institute in New York. She graduated in 1855, and upon her return to Ypsilanti, became the first female physician in Washtenaw County.

William McAndrew (1824–1895), the husband of Helen, was a cabinetmaker and carpenter. He shared his wife's sense of social responsibility, and both were active in the Antislavery movement. They were members of the Underground Railroad and hid escaping slaves in their barns. The two were also active in the Women's Suffrage movement and the Temperance movement. In their later years, William and Helen joined the Salvation Army.

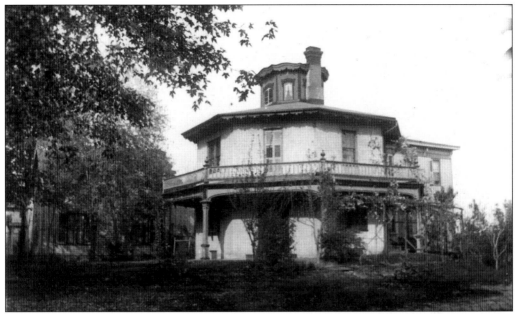

At 105 South Huron, William built an octagonal house for his wife's practice almost entirely by himself. When Helen added a "Water-Cure" Sanitarium in 1870, William built a three-story addition to the house. This is a testament to his skill, as an addition to an octagon is extremely difficult. The house was destroyed by fire in December of 1983.

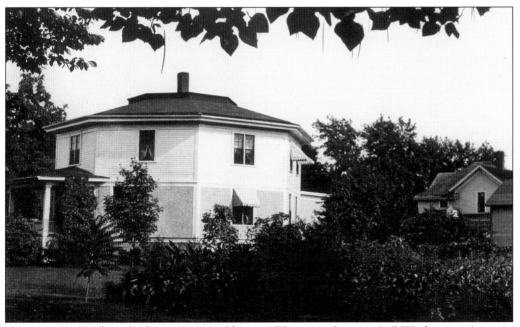

At one time, Ypsilanti had two octagonal houses. The second was at 915 Washtenaw Avenue, as seen in this picture from about 1915. Tales were told of the house being used as a station in the Underground Railroad. The house was moved from its original location in May of 1966, to make room for an apartment house. The octagonal house now stands at 114 North River, and is the SOS Crisis Center.

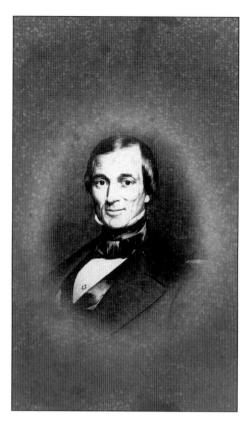

Elijah Grant (1801–1851) moved to Ypsilanti in about 1834 and opened a dry goods business. It was in real estate, however, where he made his money. Grant had made a fortune by the time of his death. According to local legend, Elijah had a provision in his will that would have disinherited his son Edward, if Edward married during the life of his mother Mary. Elijah, it seems, was concerned about the hostile relationship that might develop between a mother and her daughter-in-law.

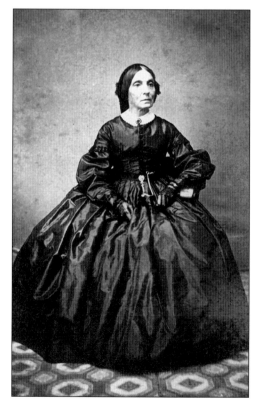

After the death of her husband, Mary Grant (1803–1883) spent the rest of her life living in the family home on Washington Street, with her son, Edward, an only child. When she died at the age of 80, she left Edward alone in the world with a fortune.

When his mother died, Edward Grant (1838–?) was 45 years of age. He seems to have been a man who could have used a good wife. Instead, he spent his life alone. He left his house each morning dressed in a frock coat, gray striped trousers, a silk hat, and patent leather boots, and spend the day standing motionless at the entrance of a store on Michigan Avenue.

After the death of his mother in 1883, Edward Grant spent his inheritance on good living and bad investments. As his fortune dwindled, he sold the furniture in his house at 218 North Washington Street, piece by piece and room by room. Edward sold his house to the Ladies' Literary Club in 1913. Edward died penniless. The Ladies' Literary Club still owns the house, which was placed on the National Register of Historic Places in 1934.

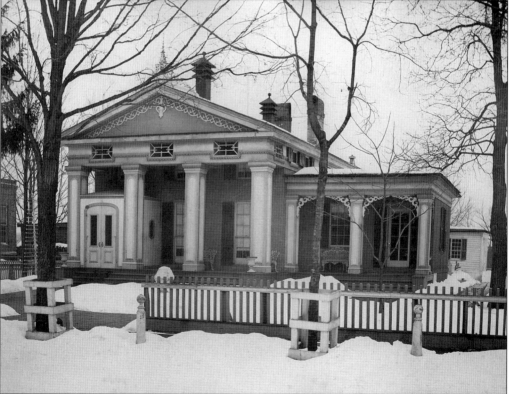

Philo Ferrier (1820–1912) came to Ypsilanti in 1857 to finish the original Presbyterian Church begun by his brother John, who died before the work was completed. After the work on the church was done, Ferrier went into the foundry business. He made flour mill machinery at his factory on River Street. When his son Charles became interested in the business in 1870, the firm was renamed Philo Ferrier & Son. When they took on a new partner in 1884, the name was changed again to Ypsilanti Machine Works. The firm enjoyed a splendid reputation throughout the years it was in business.

Built in 1840, the Mill Works Building on River Street is one of the oldest buildings in Ypsilanti. For many years this was the home of Philo Ferrier's foundry and machine shop. After his death in 1912, his son Charles carried on in the business. Today, the building is the home of the Ypsilanti Food Co-op.

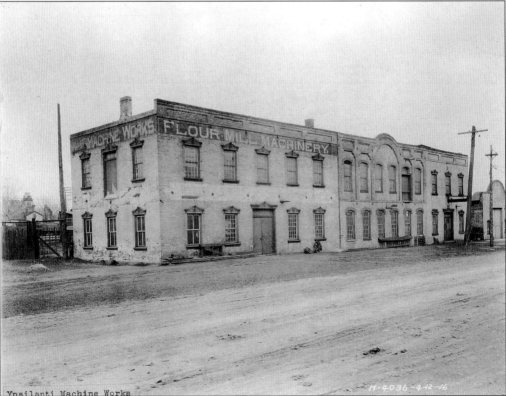

Ypsilanti Machine Works

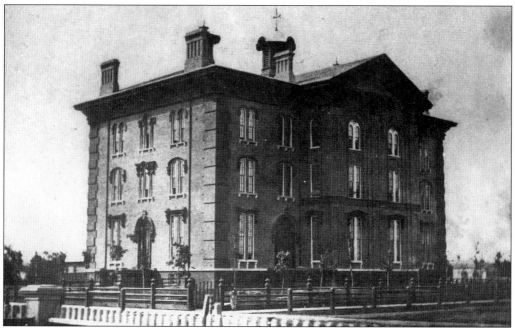

The Union School was dedicated August 17, 1858, and stood on the northwest corner of West Cross and Washington. When completed, at a $40,000 cost, it was the largest and most expensive Union School in the state. It seems to have been money well spent, as *The New England Journal of Education* said: "It is the finest school building of its kind in America." The building was destroyed by fire on December 9, 1877.

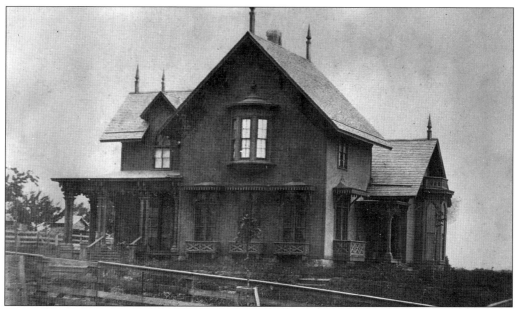

This is the home of Prof. Albert Miller, at 518 West Forest, in 1859. Miller was Professor of Music and German at the Normal School between the years 1854 and 1866. "Albert Miller," reported *The Ypsilanti Commercial* of November 7, 1869, "to Watson Snyder 40 acres of land and Gothic home on Forest Avenue." The house no longer stands.

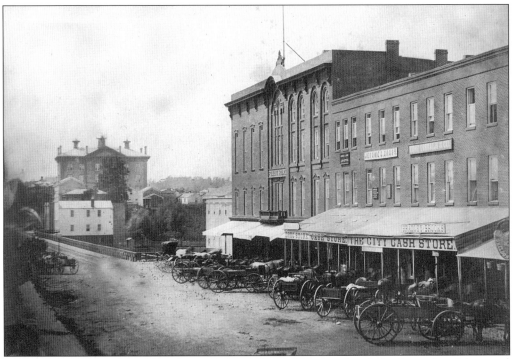

When the Follett House opened on July 4, 1859, it was considered the finest hotel between Detroit and Chicago on the Michigan Central Line. The hotel had a dining room on the second floor and a ballroom on the third. The ballroom provided a stage for such notable persons as Buffalo Bill Cody and General Tom Thumb. It has been speculated that the first basketball game in Michigan was played in the Follett House ballroom.

Benjamin Follett (1819–1864) was the son-in-law of Mark Norris, and like Norris, Follett was one of the early builders of Ypsilanti. Follett was a banker, with interests in lumber and real estate. He was a partner in the building of the Huron Hotel, and, after buying out his partners, renamed the hotel the Follett House. He gave a speech on the founding of the Highland Cemetery and its dedication on July 14, 1864, and died only a few months later, becoming one of the first to be buried there.

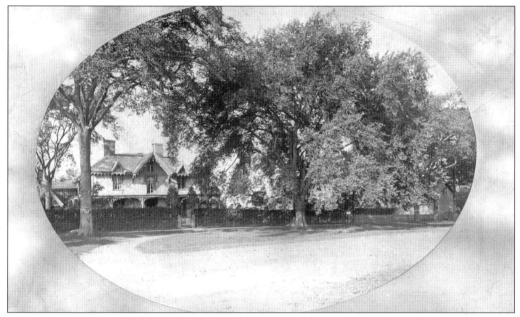

Mark Norris gave his daughter Elvira and son-in-law Benjamin Follett a house when they moved back to Ypsilanti in 1840. The Follett mansion stood on River Street between Oak and Maple. Over the years, the house was transformed into a showplace and social center. Follett kept up with the times, and his was the first house in Ypsilanti to have a conservatory, as well as the first to be lighted by gas. After the death of Elvira in 1888, the house fell into disrepair, and was removed in 1904. This photograph is from the 1870s.

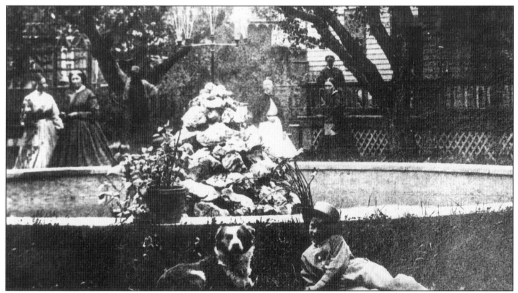

The grounds of the Follett mansion were also impressive. The house stood under a gorgeous grove of oak trees. Benjamin Follett was the first in Ypsilanti to take care of his lawn, and had fine hedges and a curved drive. Follett had the first windmill in Ypsilanti. Built in a grove on a hill behind his house, he used it to pump water to a large fountain on the grounds of his house. This photograph dates back to the 1870s.

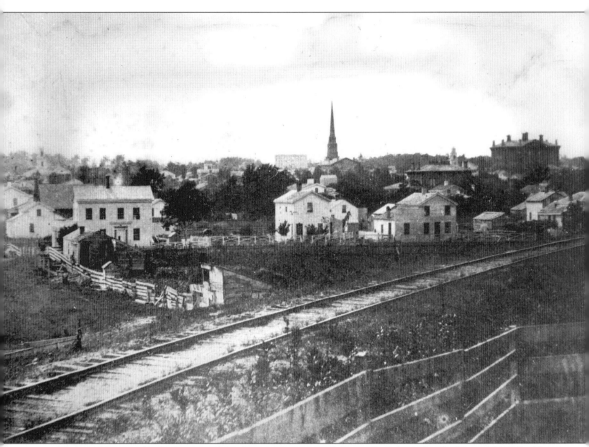

This is the view looking west from Grove Street and the railroad tracks, before 1859. Visible in the center of the picture is the tall spire of the Presbyterian Church, and to the right is the Second Seminary Building.

Three
THE 1860s

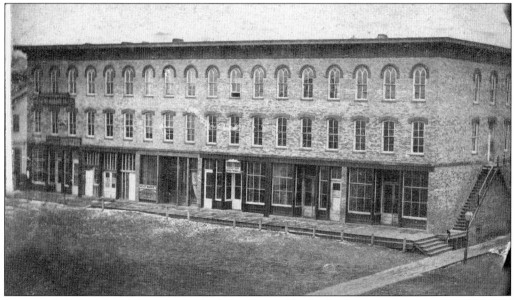

Built in 1861 by Mark Norris and called the Norris Block, the Italianate structure at 404–412 North River Street was intended for retail and residential use. Instead, it was used as a barracks by the 14th Michigan Infantry Regiment in 1862, when this photo was taken, and by the 27th Michigan Infantry Regiment in 1863. It might be the only building still standing in Michigan used as a barracks during the Civil War.

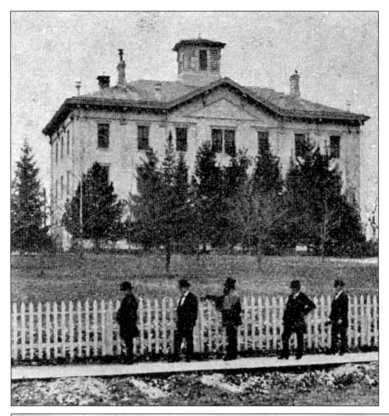

After the Normal School building was destroyed by fire in 1859, it was rebuilt and ready for occupancy by April of 1860. The first floor had a laboratory, a small apparatus room, a museum, a reception room with a seating capacity 60, and small rooms used for a model school. The second floor had a small library, a music room, and a chapel, also used as a general assembly room. The third floor had the men's study hall, drawing rooms, and a recitation room for mathematics and the study of ancient and modern language.

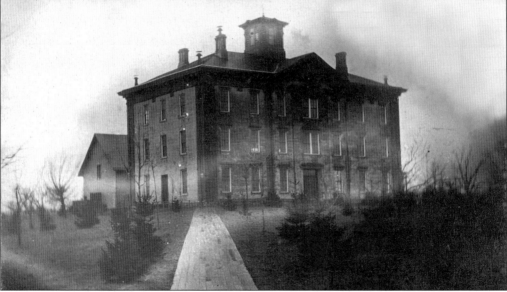

Pictured here is the second Normal School building, in about 1861. The wooden structure behind the Normal building is the first gymnasium. The gymnasium was on the second floor, with a wood room and two sets of privy closets on the first. The gymnasium was destroyed by fire on August 1, 1873. The cause of the fire was arson. The *Ypsilanti Commercial* called the loss of the building "a good riddance."

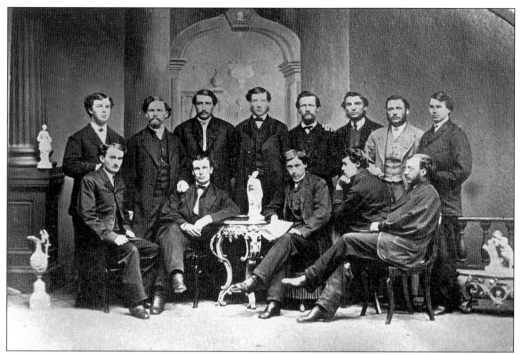

After the founding of the Normal School, student societies formed to encourage intellectual development, often with the active participation of faculty members. The Lyceuin was the first society founded at the Normal, and enjoyed a long history of hosting interesting and often spirited debate. This photograph shows the members of the Lyceuin in the mid-1860s.

Austin George (1841–1903) was a student at the Normal during the outbreak of the Civil War. He was instrumental in recruiting a company of volunteers from the student population, a group which later became Company E, 17th Michigan Infantry, called "The Normal Company." George could not serve in the army because he had lost his right arm in a milling accident at the age of 12. He went to the front as company clerk. He returned to the Normal in 1879, as chair of Literature and Rhetoric. There he was active in the improvement of the school and city for the rest of his life.

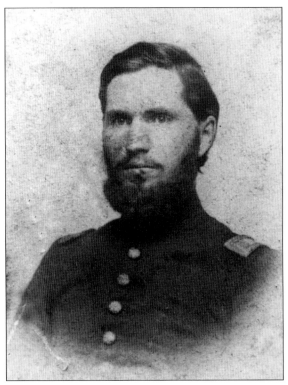

Gabriel Campbell (1838–1923) graduated from the Normal School in 1861 and served as a Captain in the 17th Michigan Infantry during the Civil War. Unlike many other veterans, Campbell resumed his education after the war, attending the University of Michigan, the Chicago Theological Seminary, and the University of Berlin. He was ordained a Congregational minister in 1868. He was a professor of philosophy at the University of Minnesota, and later chair of philosophy at Bowdoin. From there he went to Dartmouth College in New Hampshire.

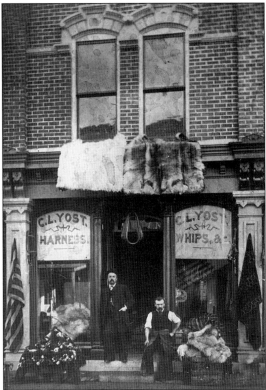

Seen here is the harness shop of Chester L. Yost in the Depot Town section of the city, sometime in the early 1860s. Yost later became a dealer in horses and carriages. It was said that he handled more horses than any man in the county. During the Civil War, Yost was commissioned to purchase horses for the cavalry. He was drafted into service, but arranged for a substitute.

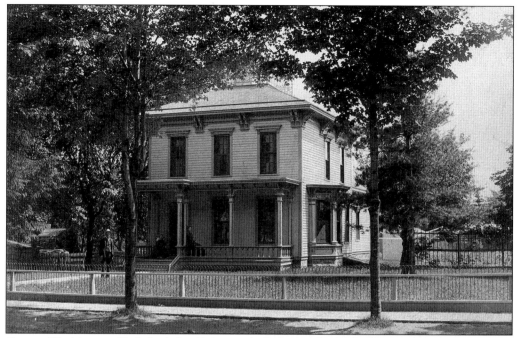

George Washington Cady had this Cubist-style Italianate house built at 302 Oak Street in the early 1860s. Cady was a saloon keeper whose business was at 52 East Cross, in what is now known as the Art Train Building. In this photo, George Cady stands in front of his house while his wife, Mary Victoria, sits on the porch with their daughter, also named Mary Victoria.

George W. Cady, third from left, stands in front of his saloon, at what is now 52 East Cross, in the Depot Town section of the city. As a saloon keeper, Cady had something of an unsavory reputation.

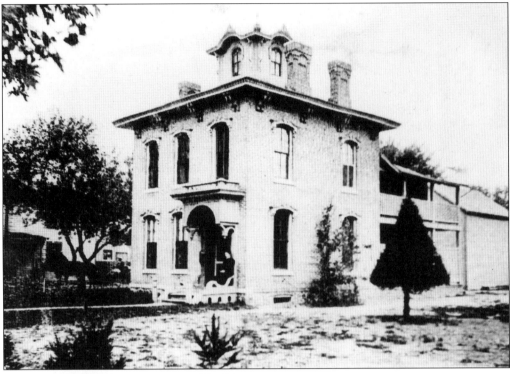

FREDERICK H. PEASE
STATE NORMAL COLLEGE, YPSILANTI, MICH.

Fr. Edward Van Pammel, a Belgian, was the pastor of St. John the Baptist Catholic Church in 1862, when he purchased two lots adjoining the property. The rectory was completed the following year, and remained in use until 1934.

Frederick H. Pease (1839–1909) was appointed Professor of Music at the Normal School in 1863. Pease held the position for the rest of his life. Before his appointment, the Music Department had provided only rudimentary instruction for teachers. Pease turned the department into one of the leading music schools in the state.

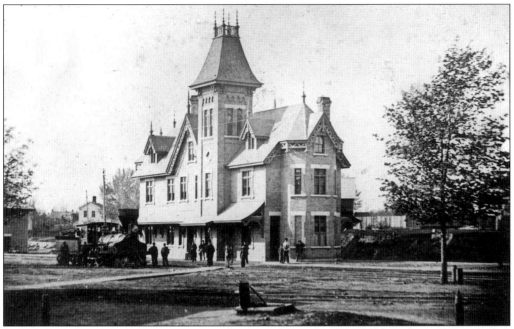

A three-story brick railroad depot with a tall tower was built at Ypsilanti in 1864. When finished, it was considered the finest depot on the Michigan Central line, which ran between Detroit and Chicago. The depots at Detroit and Ann Arbor were compared to barns.

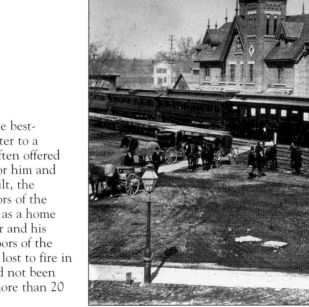

In order to attract the best-qualified station master to a depot, the railroad often offered to provide housing for him and his family. When built, the second and third floors of the depot were intended as a home for the station master and his family. The upper floors of the Ypsilanti depot were lost to fire in May of 1910, but had not been used as a home for more than 20 years.

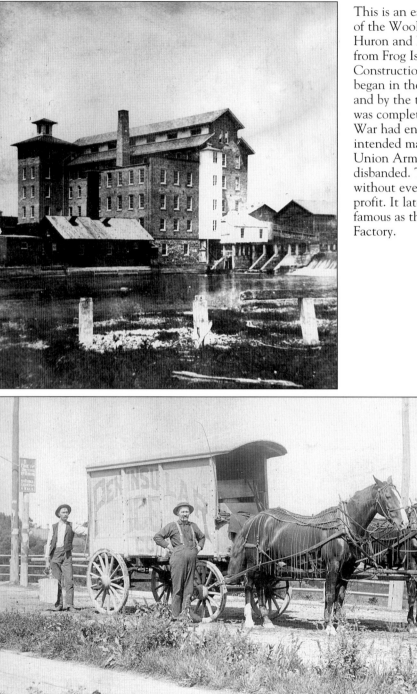

This is an early photograph of the Woolen Mill at Huron and Forest, as seen from Frog Island. Construction of the mill began in the spring of 1865, and by the time the work was completed, the Civil War had ended and the intended market, the Union Army, had disbanded. The mill closed without ever making a profit. It later became famous as the Underwear Factory.

Jacob Grob is seen standing next to his ice wagon in this 1866 photograph. Grob is credited with founding the first brewery in Ypsilanti. Grob moved to Ypsilanti in 1861 at the age of 22, married Sophie Post, and erected a small brewery at his home on Forest near the bridge. He built an extensive ice house in 1864. Grob moved exclusively into the ice business by the late 1880s.

Henry R. Scovill (1843–1929) was a veteran of the Civil War who went into the lumber business with Joseph Follmore in 1869. They opened their saw mill and lumber yard at the Forest Avenue end of the island, north of the Cross Street Bridge. It was Scovill who named the island "Frog Island." Scovill was a member of the Volunteer Fire Company, and was mayor of Ypsilanti for five one-year terms. He remained active in business until the day he died, when he was killed in an accident after leaving the lumber yard.

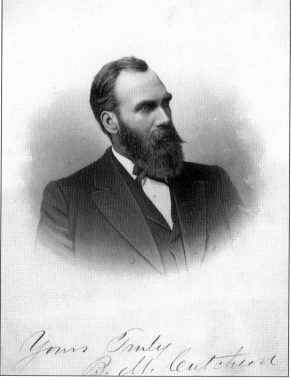

Byron Cutcheon (1836–1908) was the principal of the Ypsilanti High School during the outbreak of the Civil War. He enlisted in the 20th Michigan Infantry Regiment in 1862 and held the rank of major by 1863. He was awarded the Congressional Medal of Honor for "distinguished gallantry" at the battle of Horseshoe Bend. By the end of the war, he held the rank of brigadier general. After the war, Cutcheon moved to Manistee and served in the U.S. House of Representatives (1882–1890). He returned to Ypsilanti near the end of his life, in order to be closer to his sisters.

As a young woman, Florence Babbitt (1847–1929) was an active member of the community. She was a member of the Daughters of the American Revolution, the Order of the Eastern Star, the Ladies' Literary Club, the Episcopal Church, the Parish Aid Society, and the Pioneer Society of Michigan. It was Babbitt who raised the funds for the Civil War Memorial in Highland Cemetery.

David Porter Mayhew (1817–1887) was named Acting Principal of the Michigan State Normal School in 1865, upon the resignation of Adonijah Welch. This was intended to be a temporary arrangement, but Mayhew remained until 1870. It was said that Mayhew could make no one his enemy and everyone his friend.

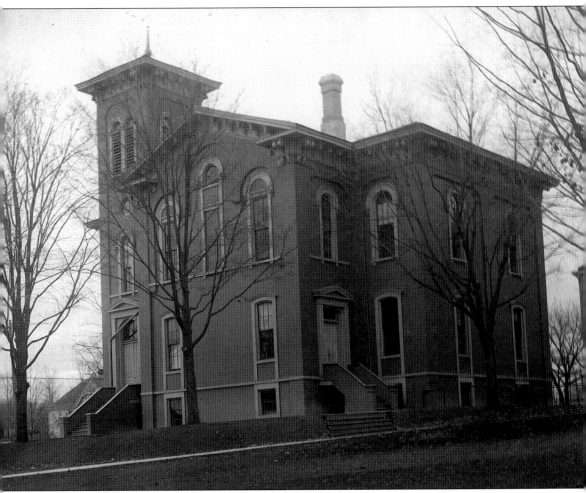

The Normal Conservatory Building stood on the northwest corner of Cross and College Place, and was originally intended to be a museum and library for the State Agricultural Society. Delays in construction and other problems caused the society to lose interest in the project, and the building was turned over to the Board of Education in 1868. From 1870 to 1882, the building was used as a training school. Then, in 1882, it was used by the Conservatory of Music. The Conservatory continued to use the building until 1915, when it was demolished to make room for Boone Hall.

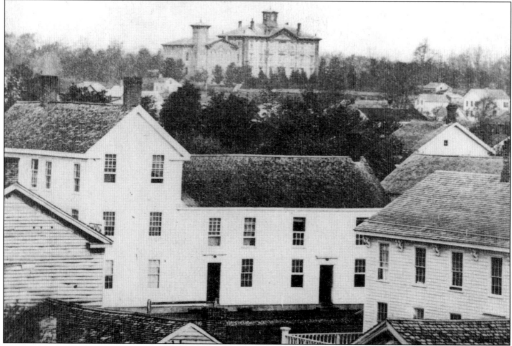

Visible in the background are the Normal Conservatory and the second Normal building. The building in the foreground is the Barton House Hotel. This stood on the northwest corner of Pearl and North Washington. The Barton House was demolished in 1891.

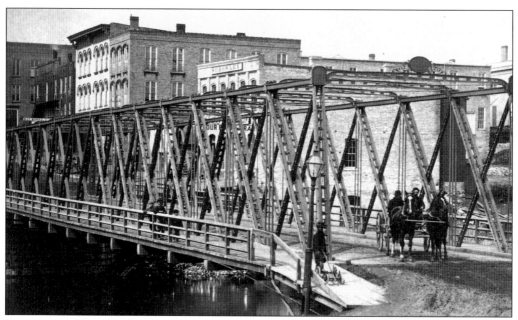

Everyone could see Ypsilanti was an up-and-coming community in 1868, with the construction of the Congress Street Bridge (now Michigan Avenue). It was an iron truss bridge with abutments of Joliet Stone. The sign on the right side of the bridge reads: "$10 Fine for Riding or Driving Across This Bridge Faster Than a Walk. Post No Bills!" The bridge was replaced in 1893.

Four

THE 1870s

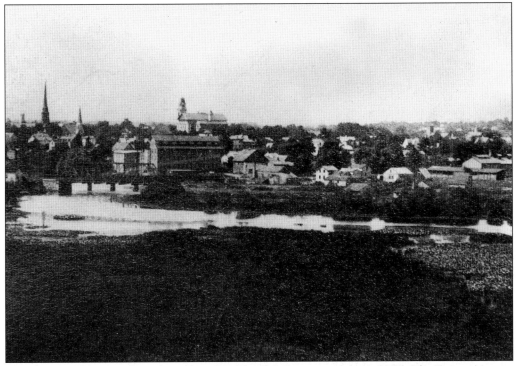

Seen here is the view of Ypsilanti from Highland Cemetery, in about 1875. The Forest Avenue Bridge is at left. The large building to the right of the bridge is the woolen mill, later known as the underwear factory. Behind it is the tall tower of the Seminary. The tall spire of the First Presbyterian Church is visible at left. The smaller spire of the Baptist Church, at the corner of West Cross and Washington, is just visible.

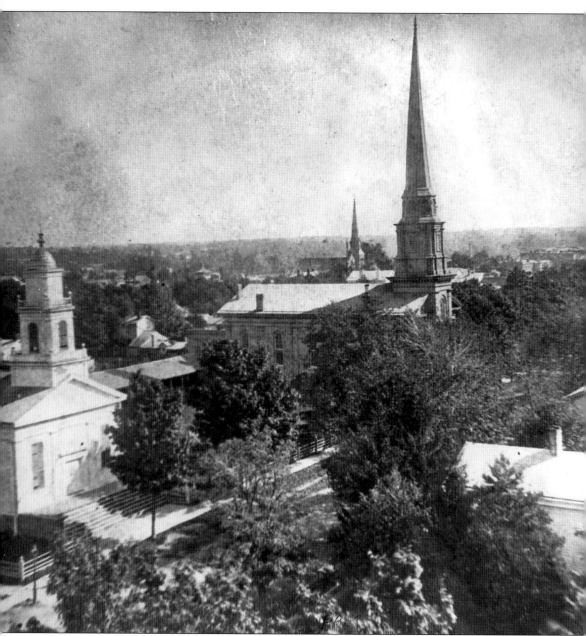

This is the view from the corner of Cross and Washington in the 1870s. At left is the First Baptist Church. At the center of the picture is the First Presbyterian Church, and visible behind it is the tall spire of St. Luke's Episcopal Church. The photograph was taken from the Union Seminary building.

Charles FitzRoy Bellows (1832–1907) came to the Normal as a student, witnessed the inauguration of Principal Welch, and graduated with the second class in 1855. He returned to the Normal in 1867 as the chair of Mathematics. Bellows served as acting principal for a single school year in 1870 and 1871. He believed the Normal should provide its students with professional training and excluded all academic work from his classes. The State Board of Education dismissed him from his teaching position in 1891. Bellows went on to become the first principal of the Central State Normal School at Mount Pleasant, now Central Michigan University.

Joseph Estabrook (1820–1894) was principal of the Normal from 1871 to 1880, which was a period of prosperity and increased attendance. Under Estabrook's leadership, the quality of professional training improved. He was a man of physical vitality, well-developed intellect, and unusual emotional depth and strength. It was said that the world was a better place because Joseph Estabrook was in it.

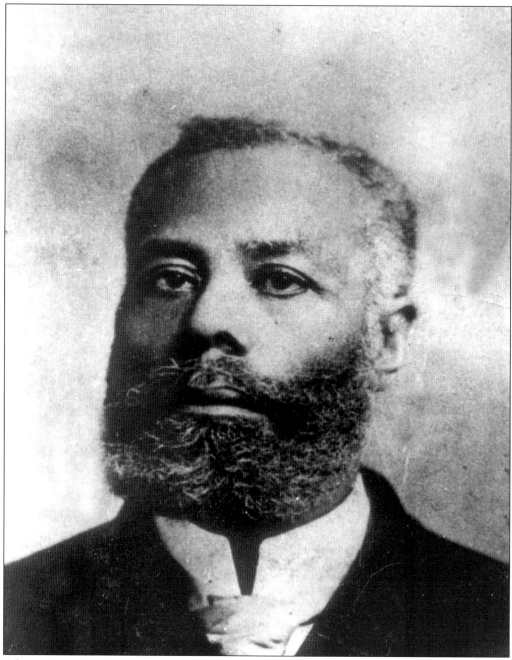

African-American inventor Elijah McCoy, the son of former slaves, was born on a farm in Ontario, Canada. After the American Civil War, his family moved to a farm near Ypsilanti. As a young man, McCoy studied engineering in Glasgow, Scotland. Upon his return to the United States, the only employment McCoy could find was as a fireman on the Michigan Central Railroad. At this time, trains made frequent stops so that parts of the engine could be oiled. McCoy invented a lubricating cup in 1872, ending the need for the stops. Soon the market was flooded with cheap and inferior knock-offs. Railroad purchasing agents began asking, "Is this the real McCoy?" At the time of his death in 1929, Elijah McCoy held 80 patents.

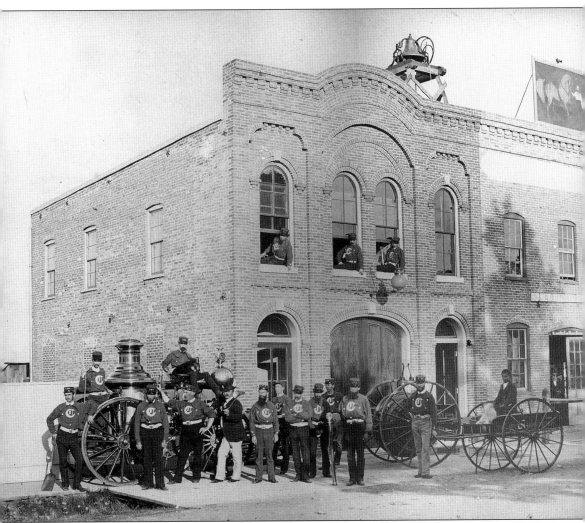

The Ypsilanti Volunteer Fire Department was organized in 1873. The department was called the Cornwell Company, because the Cornwell family had donated $1,000 toward the purchase of a Third Class Clapp & Jones Steam fire engine. This act of generosity was motivated by the fact that the Cornwell family paper mill, just south of the city, had been damaged by fire twice in two years. The engine was kept ready at the fire house, at 21 South Huron Street. The company remained there until the completion of the Cross Street Fire House in 1898.

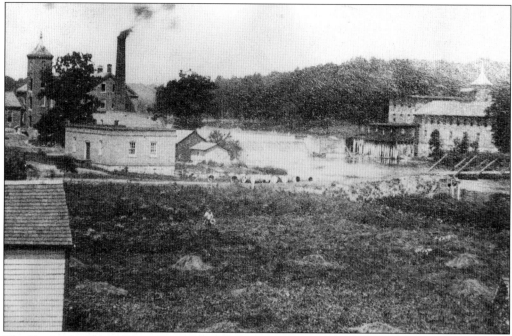

The Peninsular Paper Company was founded in 1867, with a capital stock of $50,000. The mill had a contract to provide paper to the *Chicago Tribune,* which insisted that a second mill be built far from the first, so that in case of fire, the supply of paper would continue. The second mill was built in 1873 on the north side of the Huron River, and was destroyed by fire in 1898. As soon as the *Chicago Tribune* learned of the fire, it canceled its contract with the Peninsular Paper Company. The Peninsular Paper Company continued its operation until June of 2001.

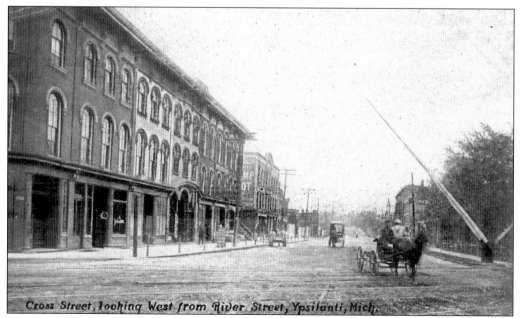

This is a view of Cross Street looking west from River, perhaps in the 1870s or maybe the 1880s. Depot Town has changed little over the years. Note the old-fashioned railroad crossing gate.

Frederick L. Swaine (1850–1897) was a native of England who visited Ypsilanti in 1871. He was so pleased by the community that he decided to live the rest of his life there. Swaine entered the malt business in 1872, and became active in the cultural, political, and social affairs of the city.

Swaine purchased the malt house on the northeast corner of River and Forest in 1872. Malt is an ingredient of beer. Originally built as a schoolhouse, the building was converted into a malt house by L.C. Wallington, a previous owner. Swaine renovated it into a 50-by-90-foot, three-story brick building. He installed modern machinery and increased productivity. Most of the building was removed in the 1920s, but a part of it remains and is now a garage.

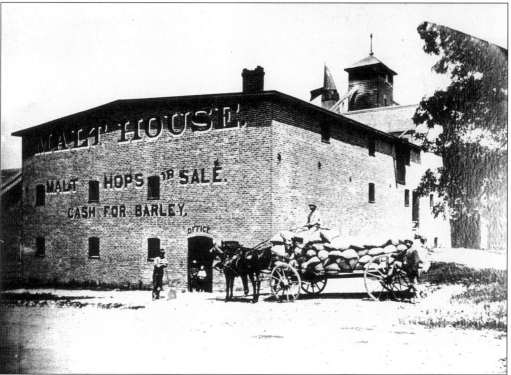

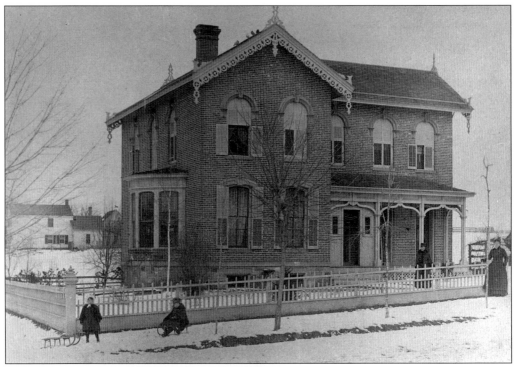

Swaine built the house at 101 East Forest in 1873, the year before he married Eliza Ann George. The family lived here for almost one hundred years, and the house is still called "The Swaine House." Today, a local landmark, this Italianate structure is still admired for its style and beauty. This photograph was taken in 1880 and shows, from left to right, Jessie Swaine, Florence Swaine, Mrs. Eliza Ann Swaine, and Josephine Dovenille, the French-Canadian maid.

Eliza Ann George (1847–1934) married Frederick Swaine on June 3, 1874. They had four children, two sons and two daughters. The daughters, Florence and Jessie, lived to reach old age and spent their entire lives in the family home. Each of the two sons died before reaching the age of three.

58

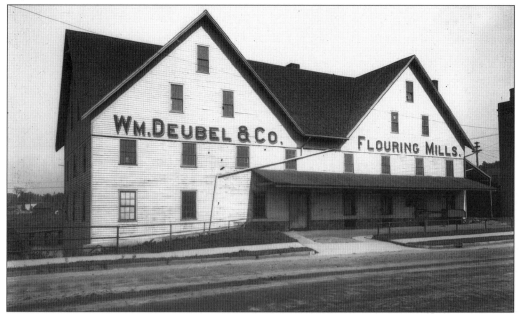

William Deubel came to Ypsilanti in 1874, and purchased the City Mill on the north side of Cross Street and on the east bank of the Huron River. Deubel operated the business with his sons James, William, and Frank. The mill had a capacity of 100,000 barrels of flour per year, with the local grist trade of 30,000 bushels of grain. The Deubels were quite clever people, and displayed the first electric light in Ypsilanti at their mill. It is said that people came and stared at the wonder for hours.

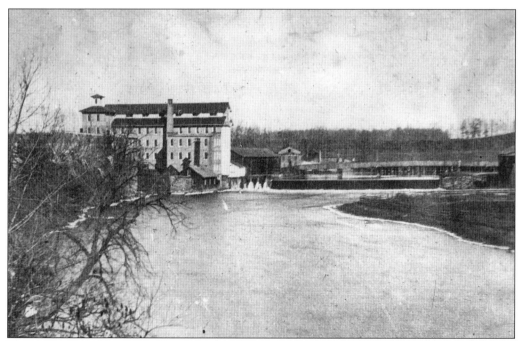

This is the view from Cross Street Bridge in about 1875. The five-story brick building is the woolen mill, built in 1865. The structure later became famous as the Underwear Factory.

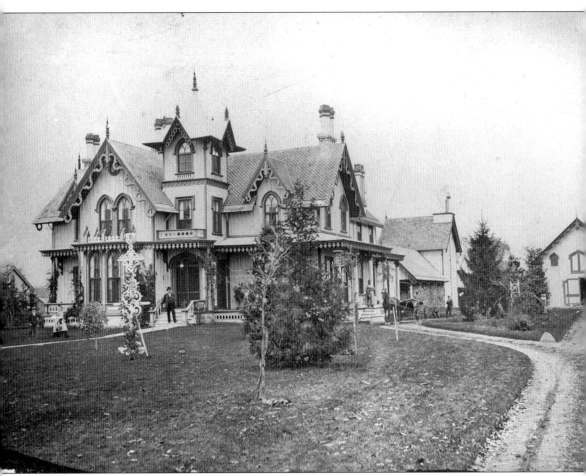

This was the home of D.B. Greene at 502 West Forest Avenue, as it appeared in the 1870s. The house stood at the foot of Ballard Street, near the campus of the Normal School. All traces of the house have long since disappeared.

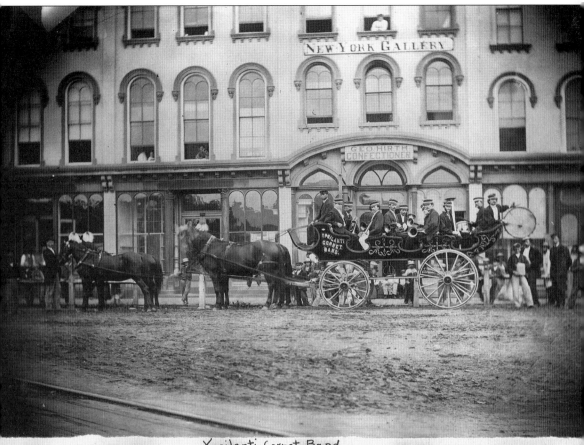

Ypsilanti Cornet Band

Taken in front of 46 E. Cross St. The teams face east. The players were identified for me by
R. Rorison but he could not say which was which, L.S.W.
Fred Cutler, cornet; Al Stuck, tuba; O.F. (Cub) Berdan, solo alto; Fred Emerick, tenor;
Oscar Rogers, cornet; Gabriel Muir, tenor; Robt. Young, baritone & cornet; James Lowden, tenor

The Ypsilanti Cornet Band was founded in the 1870s and led by Fred Cutler. The band often performed while riding in a glorious chariot of blue and gold, or marching at the head of a parade. It was said there could be no finer or more inspiring music than that of the Ypsilanti Cornet Band. Eventually the band separated, the chariot was lost, and now even the memories are gone.

Seen here is the west side of North Huron Street between Michigan Avenue and Pearl, in about 1870. Note the wooden Indian in front of the Wholesale and Retail store at left. The buildings were removed in the 1950s to accommodate a parking lot.

The Crownwell family built a paper mill at Lowell, just north of Huron River Drive and off Superior Road, in 1874. It was said to be the largest paper mill in Michigan, and employed five hundred men. As a result, a small village developed around the mill. The village had a bank and post office, but never had a store or saloon. The people of Lowell had to go to Ypsilanti for their daily needs. The mill was destroyed by fire in 1903 and never rebuilt. The village disappeared soon afterwards.

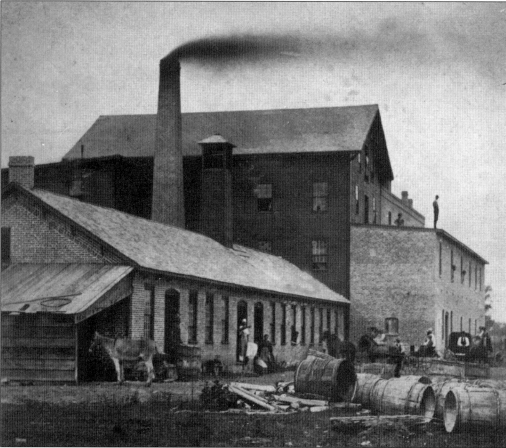

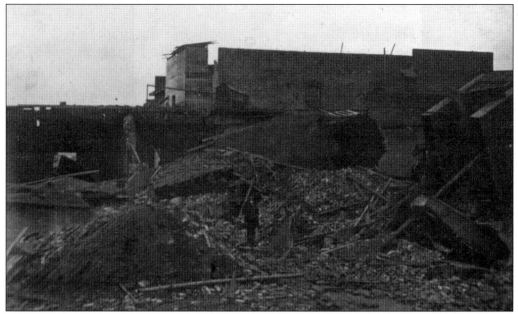

A boiler exploded at the Cornwell Paper mill, south of the city, on Friday, January 14, 1876, at about 12:30 p.m. Two men, John Max and Charles Otto, were killed. The explosion all but demolished the mill. The brick chimney, almost 100 feet high, was overthrown. The mill was rebuilt, and remained in operation until 1898.

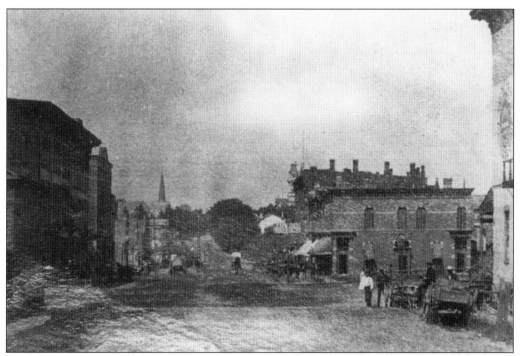

Seen here is an image of Cross Street, in what is now called the Depot Town, as it appeared in the late 1870s. The street appears very much the same today, but notice the tall spire of the Baptist church in the background.

The railroad buildings at Ypsilanti did not always consist of the depot and the freight house. For many years, the Michigan Central Railroad had section houses, storage buildings, and outhouses at Ypsilanti, as well as other structures. This photograph, taken in either 1878 or 1879, shows the stockyard just east of the tracks, where animals, such as sheep, cows, and pigs, were kept prior to shipping.

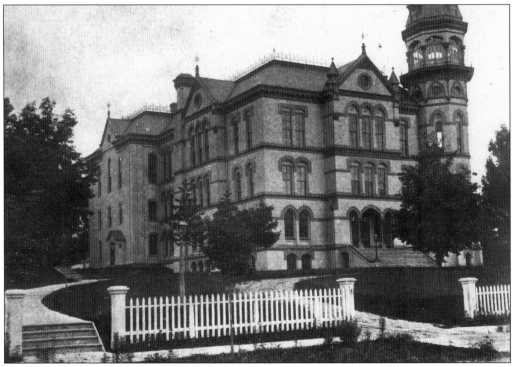

The front section of the Normal School Building was added in 1878. The construction of the bell tower at the front of the building was funded by some generous citizens of Ypsilanti.

The Bell Tower that was added to the Normal School did actually hold a bell. It was rung in the morning to summon students to class, and in the evening for vespers. Use of the bell ended around 1900, and it hung in the tower silent. When the Tower was demolished in 1948, the bell was placed in storage, where it remains today.

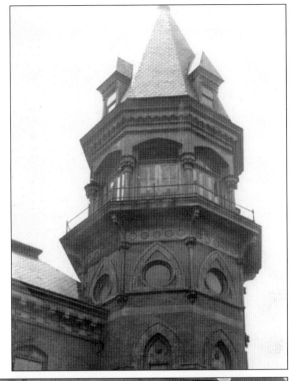

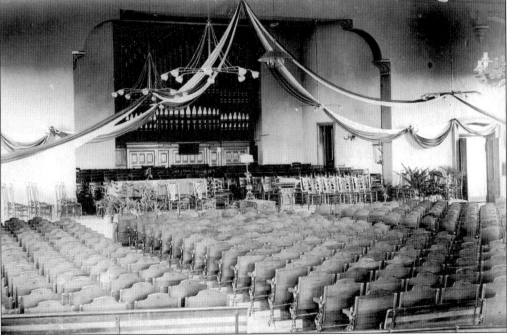

The addition to the Normal School building included the third-floor chapel. The chapel was used for prayer meetings, vespers, assemblies, concerts, and graduations. The chapel provided a stage for many guest speakers, including Theodore Roosevelt and Arctic explorer Robert Peary. Roosevelt and Peary spoke here during the same week in 1896.

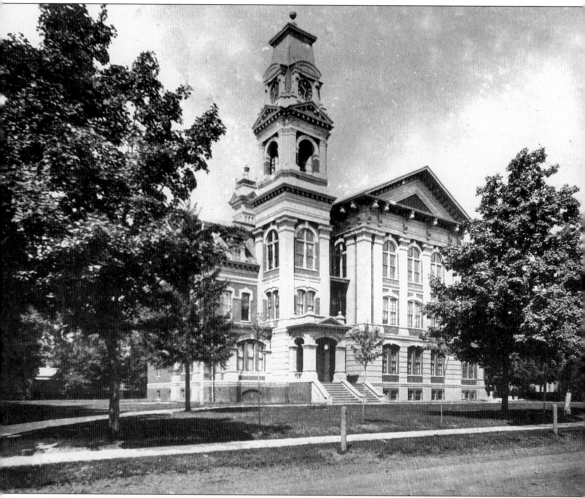

The new Union School was ready for use by the beginning of the 1879 school year. The new three-story building was quite different from the old one. The most striking difference was the 100-foot tower with clock and bell. The building was damaged by fire on May 3, 1893. The damage was repaired, and the building remained in use until demolished in 1929.

Five

THE 1880s

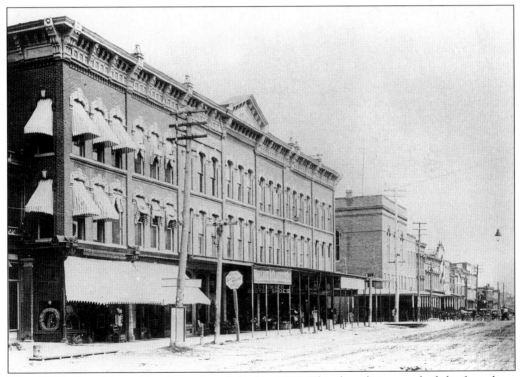

The old Hawkins House Hotel was demolished in 1879. This demolition marked the first phase of the largest construction the people of Ypsilanti had ever seen. The Union Block, now known as the Kresge Building, was built on the site of the original hotel at 200 West Michigan Avenue. This building provided space for shops and offices. Just west of the Union Block was the new Hawkins House Hotel, now made of brick. The hotel remained in use into the 1960s. Today it is an apartment house. The third part of the project was the new Opera House.

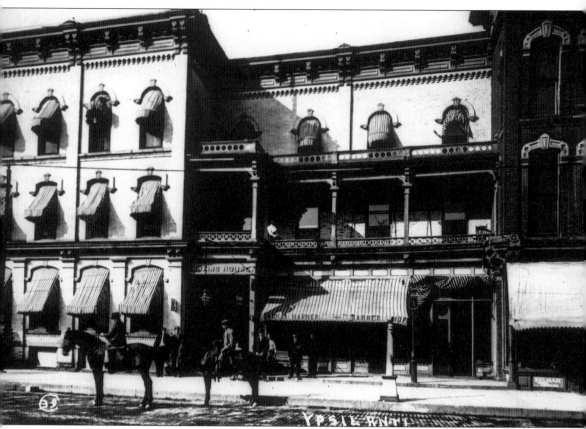

The new Hawkins House Hotel was certainly an improvement, at least in appearance, over the old one. The accommodations and room service were far better than they had been before. Still, the old building was not completely forgotten. The dining room of the original hotel was not demolished, but moved to the rear of the new building, where it remained in use until April 12, 1893.

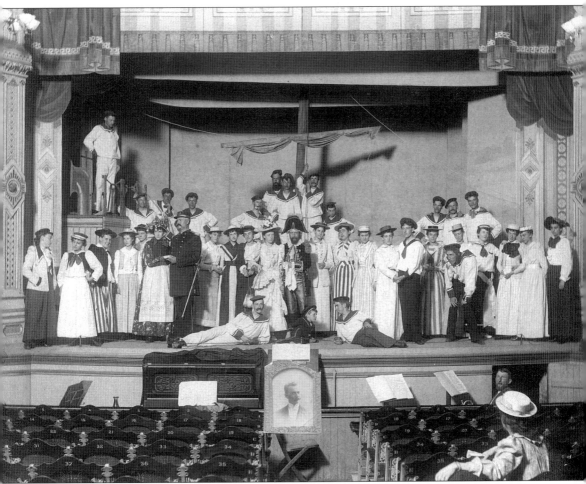

The stage of the Opera House was 28 feet wide and 33 feet deep, and was graced with performances by amateur and professional theater companies alike. The Opera House was the pride and joy of the community, and became the town's prime location for hosting public speakers, political gatherings, and temperance meetings. This photograph shows the cast from an amateur 1892 production of Gilbert and Sullivan's *H.M.S. Pinafore*.

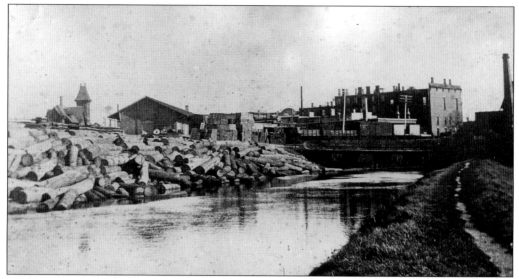

Looking south from Frog Island in about 1880, one can see the Michigan Central Depot at the left, the Freight House, and the rear of the Follett House Hotel. Visible in the picture is the building that stood behind the Follett House. The first floor of this building was used as a warehouse, and the kitchen to the hotel dining room was on the second. Food was carried to the dining room through a walkway that extended above the alley. This building was removed in the 1920s. Also visible in the picture is the raceway that made Frog Island a real island.

Edward Payson Allen (1839–1909) was the most successful politician to rise from Ypsilanti in the 19th century. He graduated from the Normal School in 1864 and then joined the 29th Michigan Infantry during the Civil War. After the war he entered the University of Michigan Law School, and graduated in 1867. Allen was a member of the city council and served as mayor of Ypsilanti in 1880 and again in 1899. He was elected to the U.S. Congress and held office for two terms. Edward Allen was held in high regard and was respected by the community.

Daniel Putnam (1824–1906) served as acting principal of the Normal School three times during the 1880s. He held the position in 1880, then from 1881 to 1883, and again from 1885 to 1886. Putnam also served on the Ypsilanti City Council and was mayor from 1889 to 1891. As a teacher, Putnam tried to mold his students into good men and women, rather then simply scholars and teachers.

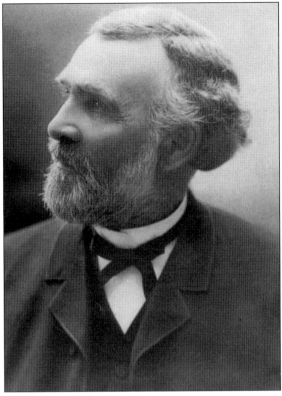

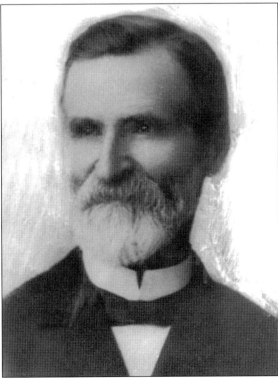

Malcolm Mac Vicar had studied for the Presbyterian ministry, but was ordained into the Baptist ministry in 1856. Mac Vicar was elected Principal of the Normal School in December of 1880. He remained only one year, and devoted himself to the work of reorganizing the course of study, the societies, and other matters concerning the school. Mac Vicar believed that mental discipline alone was not adequate preparation for life; more important was the building of a strong, reliable character.

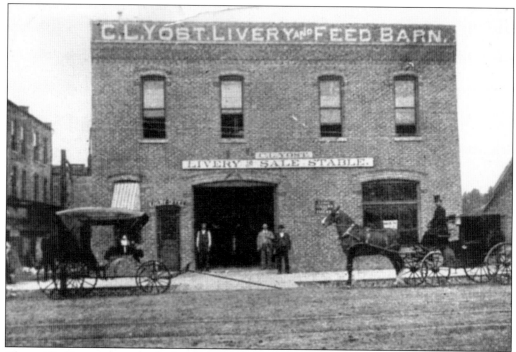

Chester L. Yost went into the livery business in 1881, and was soon said to have one of the finest livery stables in the state. He kept 20 head of horses constantly on hand, as well as the finest rigs to be found. Yost was also successful in auctioneering, especially the selling of stock. Yost's livery stable still stands, although no longer used for that purpose, at 19 North Washington Street.

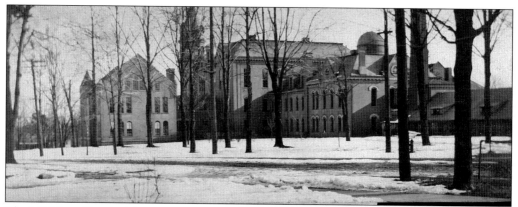

The Michigan Sate legislature appropriated $25,000 for an addition to the Normal School. The addition to the rear of the main building was 112 by 53 feet and stood two stories high. A small observatory was erected on the roof of the addition at a cost of about $700. The new addition was ready for use by September of 1882. This photograph was most likely taken in the 1890s.

Edwin Willits (1830–1896) replaced Mac Vicar as principal of the Normal in 1883. Editor, lawyer, public official, and member of congress, Willits' influence was unlike anything the Normal had experienced before. As a member of the State Board of Education (1861–1873), he exercised a strong influence on the developing character of the school, but his time as principal (1883–1885) was too short for him to establish new policies or radical changes.

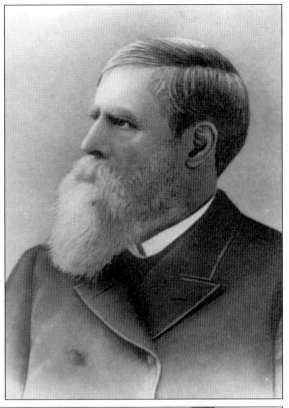

The tall spire of the Presbyterian Church proved to be unsafe and had to be removed. This photograph shows what the building looked like after the removal of the spire. The congregation was prosperous and enjoyed many years of growth. Plans were made for the reconstruction of the building.

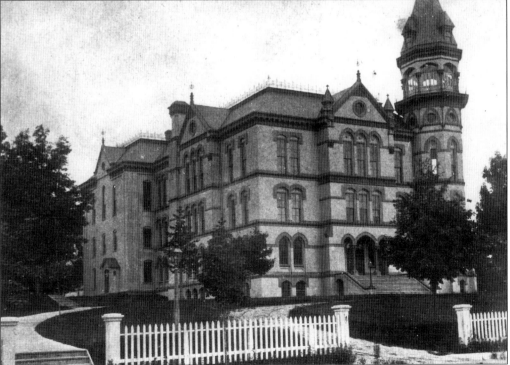

This photograph provides a glimpse at the faculty of the Ypsilanti Union Seminary during the 1880s. They are, from left to right, Miss Ada Norton, Mathematics; Robert W. Putnam, Superintendent, Mathematics; Ezra M. Foote, Music and Elocution; Miss Fanny Gray, German, History and English; James H. Shepherd, Physical Science; and A.J. Volland. The name of the dog is not known.

No matter how good the faculty, a school cannot be successful unless it has students. The students pictured here are said to be the Union Seminary class of 1883. Standing, from left to right, are Kattie Cross, Zell Baldwin, Nellie Jarvis, Joseph B. McMahon, and Clara E. Lord. Seated, from left to right, are Lutie Densmore, Anna Judd, Nellie Costello, Mary E. Lord, and Ella Cady.

The Congregationalists of Ypsilanti were part of the Presbyterian Church from 1832 until October 4, 1881, when there was a separation of the two congregations. There were 60 members in the community, including Rev. George Grannis, who became active in planning for the new church. A new brick church was erected on the southeast corner of Adams and Emmet in 1883, at a cost of $6,150. It was dedicated on July 10, 1883.

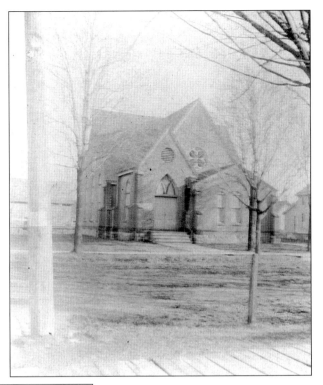

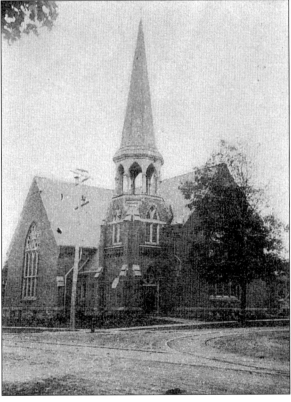

By 1881, the members of the First Baptist Church at Ypsilanti realized that they needed a new building. Later that year, the old church at Cross and Washington was removed, and the work of building a new one began on the same site. The new church, made of brick, was constructed at a cost of $30,000, and was dedicated on January 30, 1884.

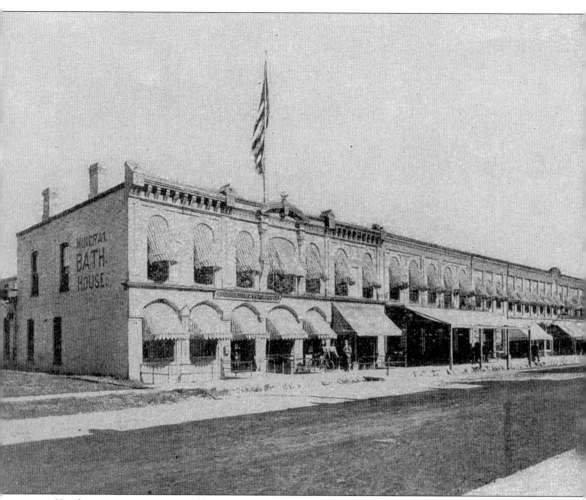

Ypsilanti was once nationally—and even internationally—known for the quality of its mineral water, which was then believed to have medical properties. The water was said to have cured cancer, rheumatism, skin disease, and almost every other ailment known to humanity, including "women's trouble." To take advantage of this resource, the Sanitarium opened on North Huron Street in 1884, to provide a place for treatment. That same year the Occidental Hotel opened next door, providing the patients with a place to stay. People came from miles away to bathe in Ypsilanti. In fact, they followed a schedule of treatment for an average of four weeks, taking at least one bath a day and drinking a predetermined amount of mineral water, which reportedly tasted awful. The Sanitarium never achieved the success expected of it, most likely because of bad management. It closed for good on January 1, 1919.

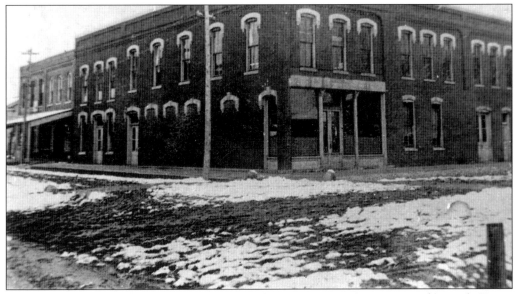

Enoch Bowling patented a perspiration proof dress-stay in 1885. In partnership with Henry Glover, Bowling started the Ypsilanti Dress-Stay Manufacturing company, which soon employed 170 girls. The plant was on the northwest corner of Huron and Pearl.

John Mahelm Berry Sill (1831–1901) first came to the Normal School as a student, and was one of the first three to graduate in 1854. He also holds the distinction of being the first male to graduate from the Normal. He was appointed principal of the Normal in 1886, a position he held until 1893. His administration was marked a time of prosperity, and was considered one of the most successful in the history of the school. After his retirement, Sill was appointed United States Minister to Korea.

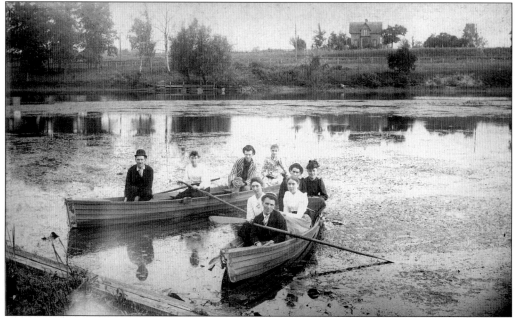

A group of friends go for a boat ride, and perhaps a picnic, at Starkweather Grove in 1887. The Huron River was once a source of recreation, where friends could go for boat rides and picnics. It may seem hard to believe today, but in the past, everyone had a favorite place to swim. One day soon, the river may again be a source of recreation.

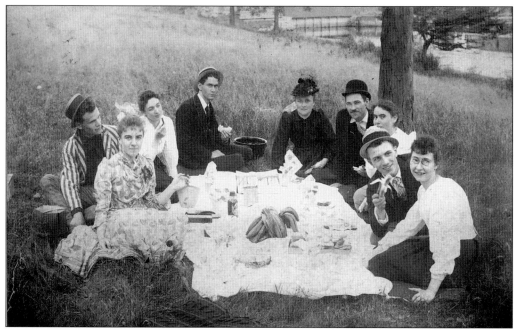

For many years, the place to go for an afternoon picnic was Starkweather Grove, as this group of friends did in 1887. They are, from left to right, William Marshall, unidentified, Bertha Goodison, William Wallace, Eunice Lambie, Benjamin Boyce, Mame Wallace, George Daman, and another unidentified friend.

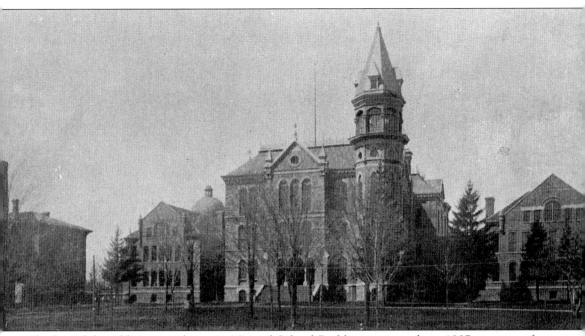

The last of the additions to the main Normal School Building were made in 1887 at a cost of $60,000. That year, the north and south wings were added to the main building. Each two-story wing was about 100 feet by 50 feet, and included connecting corridors. The library and reading room were on the first floor of the north wing, with two society rooms on the second floor. The south wing held several classrooms on the first floor and a ladies' study hall on the second. It was a building that had become even more impressive with time.

Tubal Cain Owen (1843–1913) was already a successful businessman when in 1888 he drilled on his on Forest Avenue property for a source of water for the city. At 808 feet he struck a source of mineral water, then believed to have medical value. Soon Owen was running a successful mineral water business, which he called Atlantis. He operated a small sanitarium out of his home, where Atlantis water was used in treating 32 ailments ranging from cancer and Bright's disease to sour eyes and bee stings.

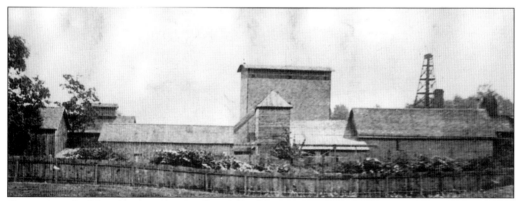

Owen soon had his property covered with buildings where mineral water was converted into products, including salts and soups, which were sold throughout the country. Owen's property on Forest Avenue was sold to the Michigan State Normal College in 1922. Today the site is occupied by Roosevelt Hall and the Jones and Goddard Residence Halls.

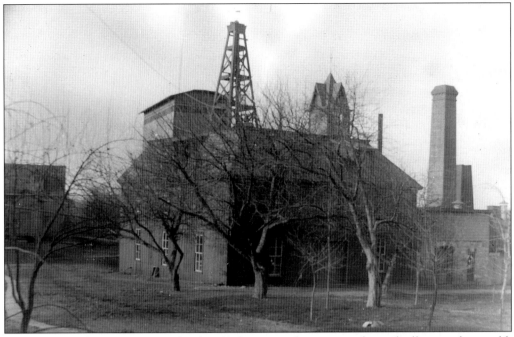

Eventually, Atlantis Water and other Atlantis products were shipped all over the world. Atlantis Water could be found on practically every steam ship and railroad dining car, as well as in the best hotels and sanitariums. Pictured here are the bottling rooms, in an 1891 photograph.

Chester Leslie Yost (1838–1908) came to Ypsilanti in 1855 as an Auctioneer, harness-maker and dealer in animal skins. His shop, which was in Depot Town, was destroyed by fire on February 3, 1860. He then moved his business to a building just east of the Follett House Hotel. Yost served as mayor from 1884 to 1886. During his term of office, he promoted a plan to purchase land west of Summit Street and south of Congress for use as a race track and park. This site is now known as Recreation Park.

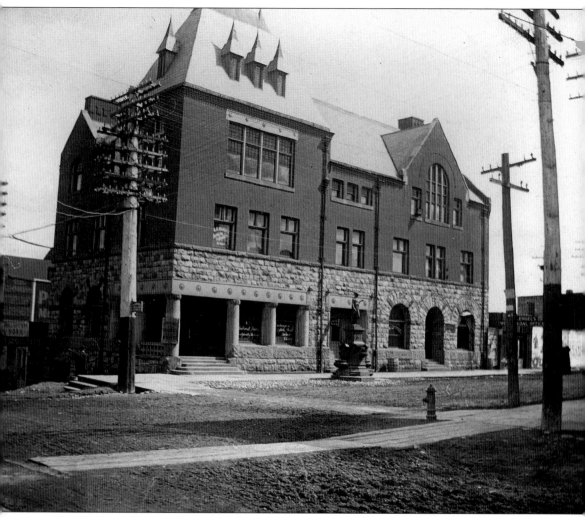

The Ypsilanti Savings Bank building, on the corner of Huron and Michigan Avenue, was erected in 1887 at a cost of about $20,000. The bank was previously known as Hemphill and Batchelder, but the name was changed upon moving into the new building. The building has been the Ypsilanti City Hall since 1974.

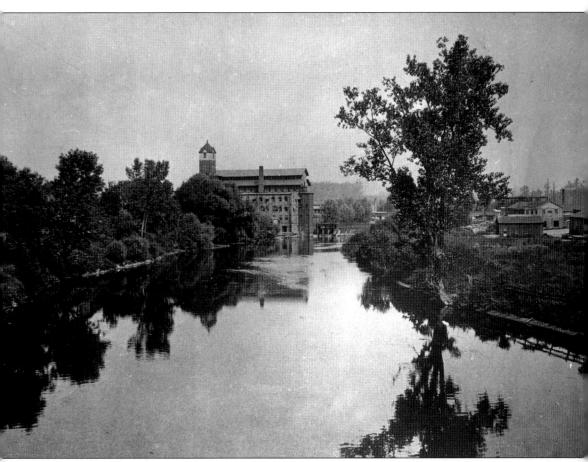

The Woolen Mill at River and Forest stood empty until 1875, when it was sold to Hay & Todd of Chicago. At first, Hay & Todd tried to manufacture anything and everything produced in a woolen mill. It was later said that they made everything out of wool except for money. In about 1887, Hay & Todd began to manufacture fine-knit underwear. The product they were best known for was the full-body, one-piece union suit. This product was so popular in some parts of the country that Ypsilanti became synonymous with union suit. The company was well known for their clever slogans, such as: "Never a rip and never a tear in Ypsilanti underwear." Another favorite was: "If love grows cold, do not despair. There is always Ypsilanti underwear."

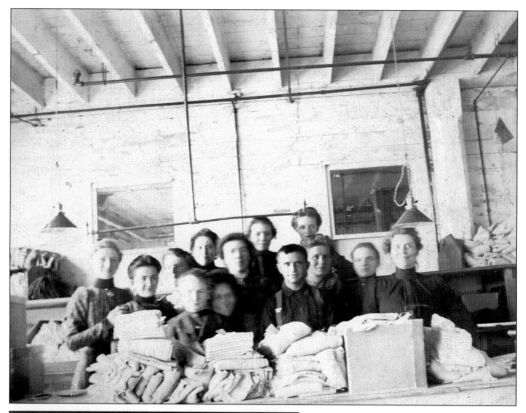

Employees of the Underwear Factory take a minute to pose for a picture. The union suit made at the factory was so popular that production could not keep up with demand, even when the factory was operating at full capacity.

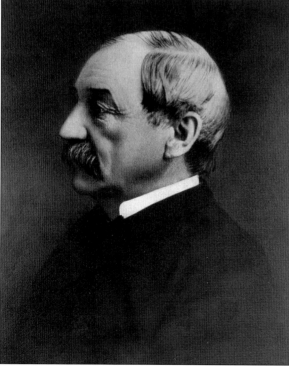

Charles S. King (1823–1891) was born in London and came to America with his father, George, in 1833. The two arrived in Ypsilanti in 1837, when George opened a grocery store on Michigan Avenue. Charles was first an assistant, then a partner, and finally head of the business after the death of his father in 1849. He continued running the business for more than 50 years. He visited the store daily, up until the day of his death.

Charles King's store at 101 West Michigan Avenue is seen here. Standing in front of the store in this 1888 photograph, from left to right, are John G. Lamb, Charles King, R.W. Hemphill Jr., and O.S. Smith. John Lamb came into ownership of the store after King's death.

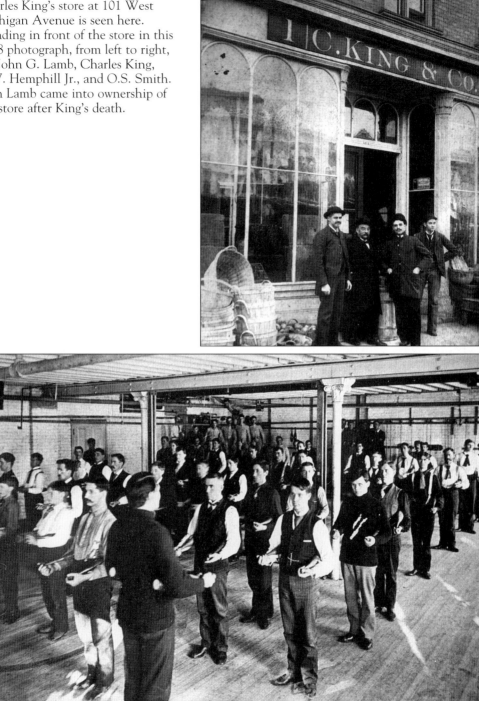

After the loss of the first Normal Gymnasium in 1873, efforts continued for classes in physical education, but these had little systematic character. Exercises were carried out in the study halls and the larger classrooms. The teachers who led the classes received no pay for their time and effort.

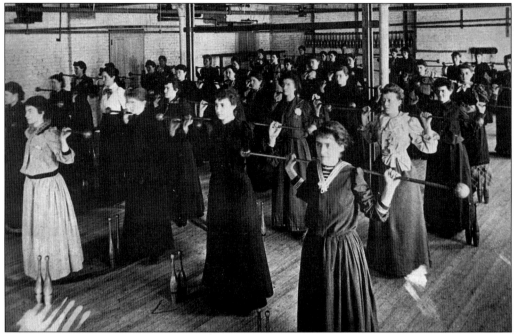

For a time, physical education was carried out in the Normal Chapel, with the teacher standing on the stage and the students in the aisles. The classes were in what was called "Swedish Work," with dumbbells and Indian Clubs. The classes were later moved to the basement of the South Wing of the Normal Building.

Ward W. Swift and his wife Helen Conklin Swift had the large frame house at 206 South Huron built in 1888. The house was the scene of many religious and charitable activities, especially those involving work for missionaries. The house was demolished in 1960 to make room for the Gilbert Residence, a senior citizens' center.

The Cleary Business College Building, on the northwest corner of Michigan and Adams, was dedicated in 1888, six years after the college was founded. The school soon became the largest business school in the state.

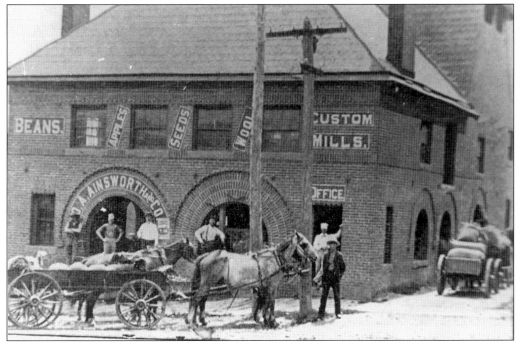

Oliver Ainsworth & Co. had their mill and elevator built on Michigan Avenue in 1888. *The Northwestern Miller* described the building as a noteworthy specimen of mill architecture. The building still stands, and has recently undergone restoration.

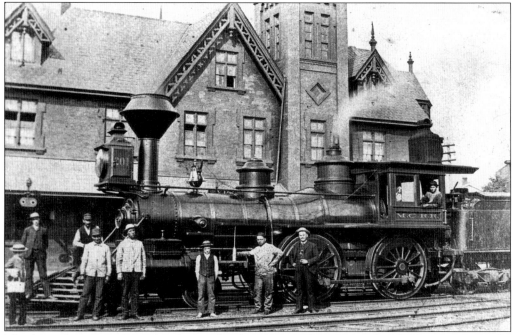

Members of a train crew, and perhaps a few friends, pose for a picture beside their engine in the late 1880s. The railroad played a major role in the economy of Ypsilanti, especially in the section now called Depot Town, whose fortunes rose and fell with that of the railroad.

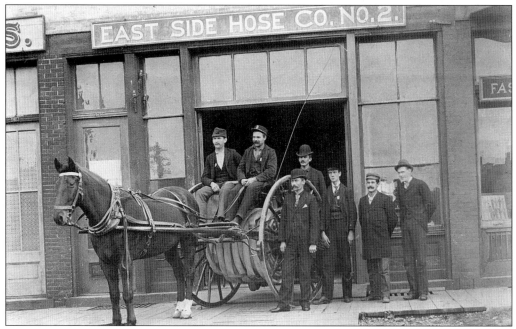

The city of Ypsilanti established a second volunteer fire company in the late 1880s to serve the east side. The company, called "Hose House No. 2," was based in the Thompson Block on River Street. This second company continued in operation until 1898, when the two companies were consolidated.

Mary Ann Starkweather (1819–1897) was one of the most notable women in Ypsilanti. She and her husband, John, moved to a farm near Ypsilanti in 1841. John was active in the community and was a successful land speculator. They moved to the house at 130 North Huron in 1883, where John died the next year. The year after, Mary Ann inherited a fortune from her uncle, Walter Loomis Newberry of Chicago. Her wealth had little effect on the way that she lived. She continued to live quietly, and used her money to present the city of Ypsilanti with gifts.

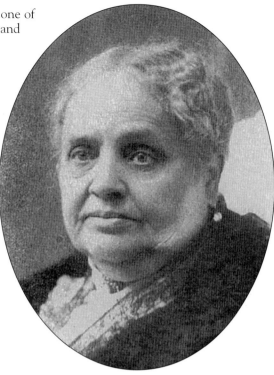

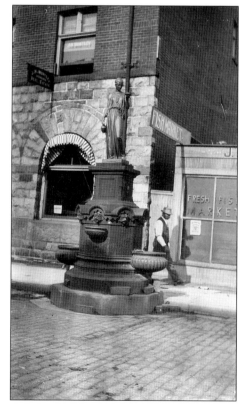

Mary Ann Starkweather gave the city a public drinking fountain in 1889. Made of bronze, the fountain stood just over 12 feet high. The fountain had separate pools of water for horses, people, and dogs. The female figure at the top is Hebe, Greek goddess of youth and cupbearer to the gods. The fountain stood on Huron street, beside the present-day City Hall, where the right turn lane is now. The fountain was placed in storage in 1932, and has since been lost.

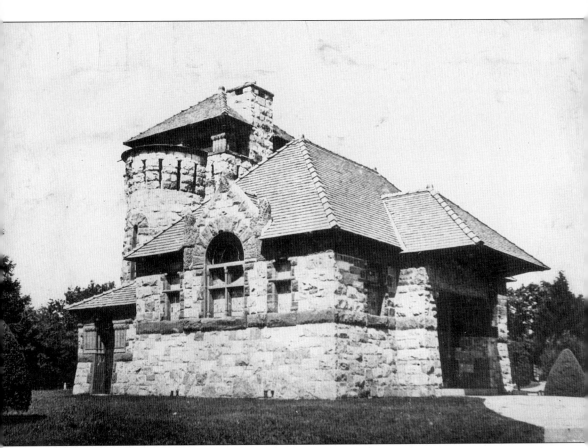

The Highland Cemetery Association accepted the gift of a chapel from Mary Ann Starkweather in 1889. This was one of her major gifts to the city. Starkweather Chapel, which stands at the entrance to Highland Cemetery, is a memorial to her husband, John, who died in 1884. The chapel was designed by George Mason and Zachariah Rice of Detroit, and is in the Richardsonian Romanesque style of architecture. The Chapel was intended for use as a cemetery chapel, where services could be held before burial, especially in inclement weather.

Six

THE 1890s

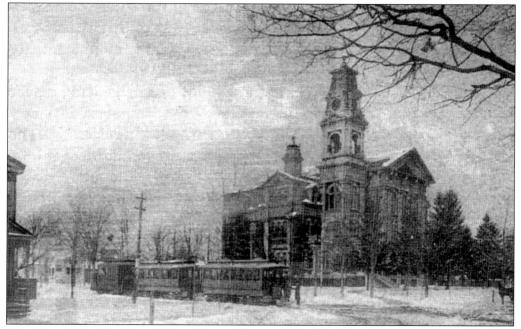

The Ann Arbor-Ypsilanti Motor Line, affectionately deemed "The Ypsi-Ann," passes the Union Seminary on Cross Street. The steam engine-driven Ypsi-Ann shuttled some 600 passengers a day between the two cities. This photograph was taken November 30, 1891.

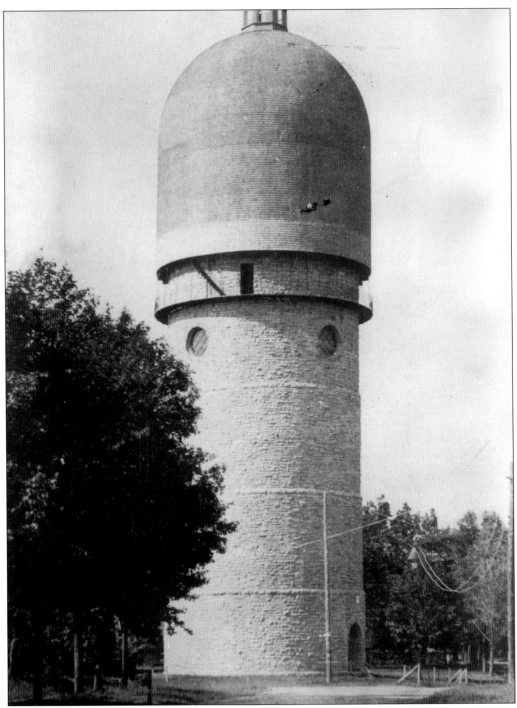

The 147-foot-high Water Tower was built in 1889 and 1890, when the city water mains were installed. The tower holds a 225,000-gallon steel tank, still used as a reservoir. When built, the tower was topped by an octagonal cupola. The cupola was removed in 1906, due to fears that a strong wind might cause it to fall into the reservoir below. The Water Tower is the most noticed landmark in Ypsilanti.

To make the best use of a water tower, also called an elevated reservoir, it must remain filled with water. For this reason, the city had to have a pumping station, which was located on the east side of Catherine Street near Harriet and the Huron River. The site is now called Water Works Park.

A Fourth of July parade passes the southeast corner of Cross and River in the early 1890s. The building in the background was extensively changed by a train wreck in the 1920s. Today, what is left of the building houses the Sidetrack.

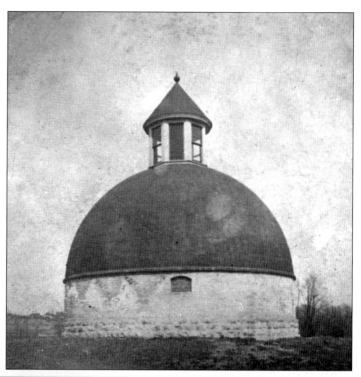

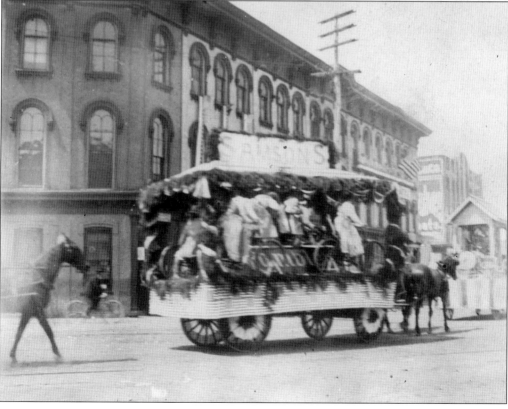

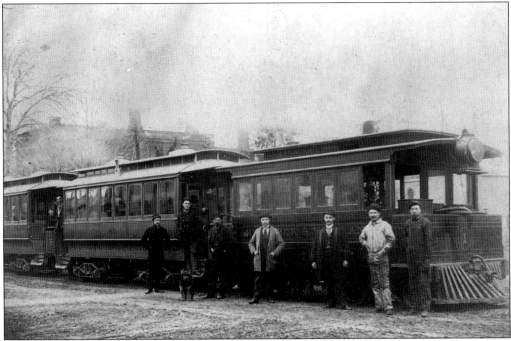

When the Ypsi-Ann began operations in 1890, the cars were powered by steam. Because horses were easily frightened, the engines were designed to look like streetcars. To the horses, the engine looked like a woodshed on wheels. The "steam-dummy" could haul up to four trailers, but carried no passengers itself.

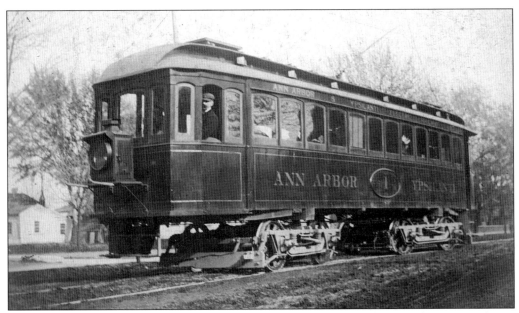

The interurban was an instant success, due, in part, to its fee of 10¢. Another reason for its success was that Ann Arbor, because of the University, had a surplus of boys, and Ypsilanti, because of the Normal, had a surplus of girls; equilibrium was achieved on Friday, Saturday, and Sunday evenings.

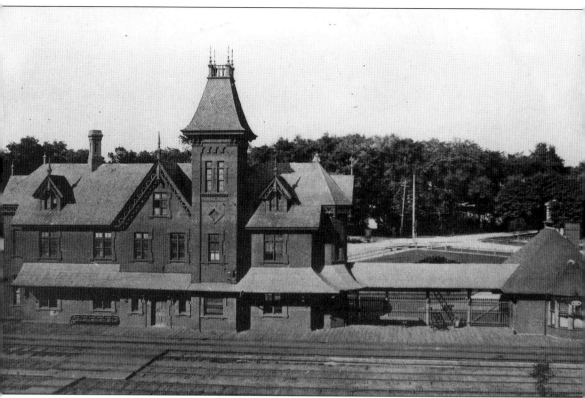

Baggage at the depot was storied in two sheds, one on each side of the depot, until 1890. That year the baggage room, with the covered breezeway, was added to the east end of the depot. The baggage room had a bay window, providing a good view of the track from each direction. The additions made an already beautiful building even more attractive.

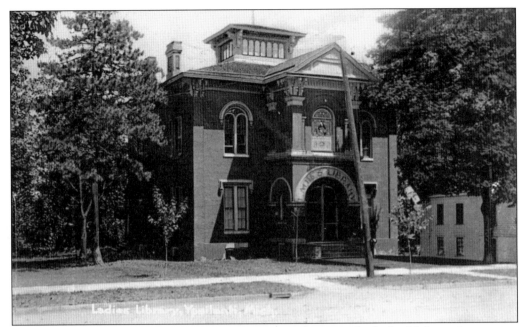

Mary Ann Starkweather gave her North Huron Street home to the Ladies' Library Association in 1890. As part of the gift, she had the front porch remodeled, and had a stained glass window from Tiffany's installed on the second floor. The building was home to the Ypsilanti Public Library until 1963. The stained glass window is now on display at the Ypsilanti Historical Museum.

Henry P. Glover (1837–1912) was one of Ypsilanti's most distinguished citizens. He ran a dry goods store for ten years, before selling out to Lamb, Davis, and Kishlar in 1888. Glover assisted in organizing the Dress Stay Manufacturing Company, and was President of the Scharf Tag Label & Box Company. He also played a major role in the founding of the Ann Arbor-Ypsilanti Motor Line, "the Ypsi-Ann." He was vice-president of the Ypsilanti Savings Bank, and served as mayor in 1891 and 1892.

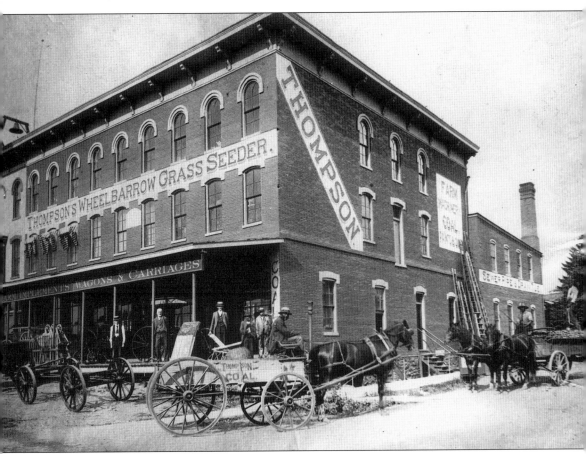

The building at 404–412 North River, shown in a 1891 photo, is known as the Thompson Block, because of its long occupancy by the Thompson family and their business interests. Oliver E. Thompson opened a paint shop in the building in 1869. Thompson began the manufacture and sale of farm implements from the building in the early 1870s. His products, some of his own invention, included root cutters, grass seeders, and kraut and slaw cutters. The family also sold porch swings, patterned wallpaper, and bicycles. The occupancy of the Thompson family ended when and last of their business interests closed in 1950.

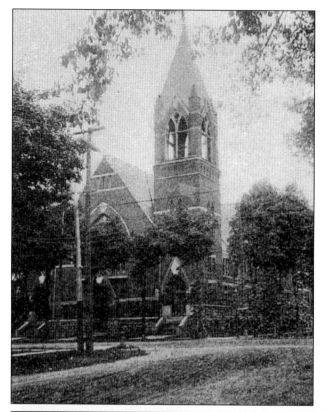

By 1889, the old Methodist Church, erected in 1843, had become inadequate for the needs of the congregation. The congregation decided it was time to build a new church, and the last service in the old one was held on July 12, 1891. The new church was dedicated on June 26, 1892. The architectural style of the building is Victorian Gothic. The building was designed according to the "Akron Plan," which designates two auditoriums that can be used separately or together. At the time of the dedication, $20,000 had been spent on construction. An additional $12,000 was raised on the day of the dedication.

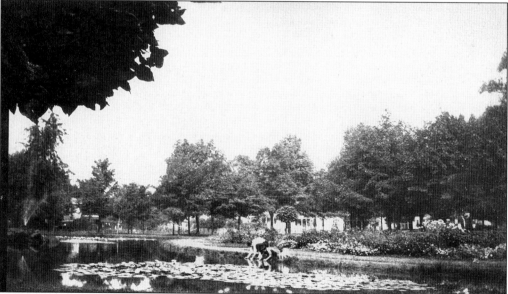

Determined to turn the abandoned cemetery at Prospect and Cross into a place of beauty, a group of young women organized the Park Improvement Society in 1892. The graves were removed, the land was graded, and walks and drives were installed. Flowers were planted, and later a crescent-shaped pond called Luna Lake was added. Prospect Park was so beautiful that people rode the train from as far away as Detroit, and even Ann Arbor, just to see the flowers.

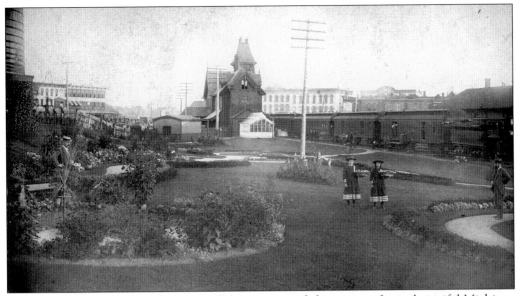

During the 1890s, Ypsilanti became well known around the country for its beautiful Michigan Central Gardens by the depot. At Ypsilanti, children boarded each train and gave boutonnieres to the female passengers. Pictured here are the first children to do so, Jessie Swaine and Lillian Damon.

John Laidlaw was the landscape gardener responsible for the fame of the Michigan Central Gardens. Born in Scotland, Laidlaw studied landscape gardening before moving to the United States. Every year, beginning in 1891, Laidlaw sculpted remarkable displays of flowers, some bearing the likeness of Masonic emblems, the Liberty Bell, and the battleship *Maine*. In 1895, Laidlaw would surpass himself.

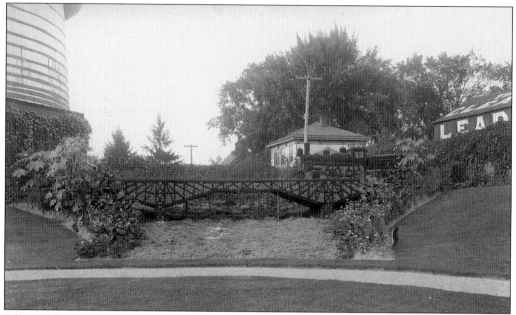

John Laidlaw used 37,000 plants in 1895 to produce a reproduction of the cantilever bridge at Niagara Falls. A train appears to have just arrived at one end of the bridge. The bridge was 45 feet long and exactly proportional to the real one. The engine was 10 feet long and the tender was 4 feet long. Beneath the bridge was a display of flowers, representing the rushing waters of the falls.

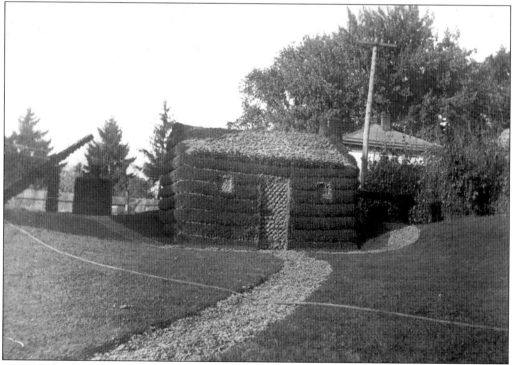

In 1897, Laidlaw designed a log cabin made almost entirely of soil and plants. The cabin was 12 feet wide, 14 feet long and 7 feet high, and contained 32,000 plants.

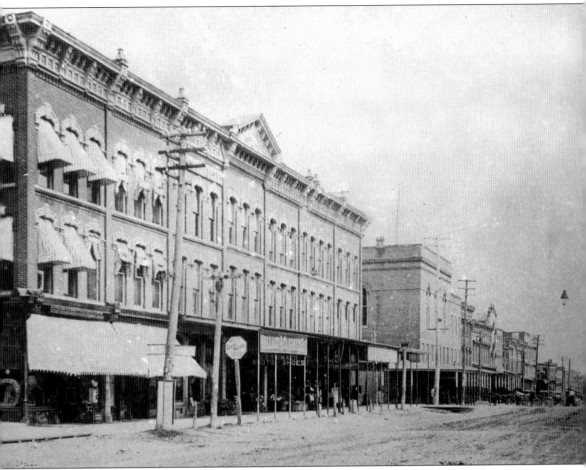

Pictured is the Union Block, better known today as the Kresge Building, as it appeared in 1893. Standing just past the Union Block on the northeast corner of Michigan Avenue and Washington Street is Hewitt Hall, built in 1851. The first true theater in Ypsilanti was on the third floor of Hewitt Hall. By 1893, the theater had become the armory of the Ypsilanti Light Guard. The third floor was removed in 1932, most likely because of concerns about its structural integrity.

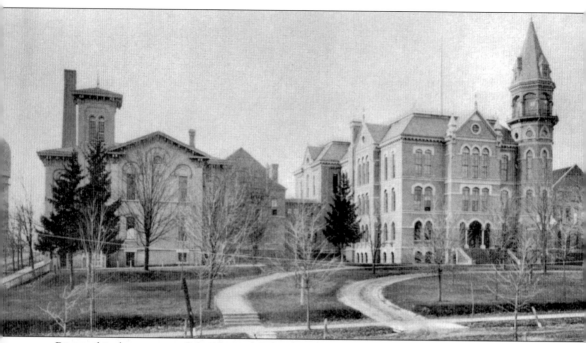

Pictured is the campus of the Normal School, as it appeared in 1893. From left to right are the Water Tower, the Music Conservatory, and the main building with the north and south wings just visible. In 1897, the state legislature authorized changing the name from "school" to "college," with respect to the four-year degree course. This was the second normal school in the nation to become a four-year, college-grade institution.

Richard Gause Boone (1849–1923) came to the Normal as principal in 1893. He possessed teaching experience at every level, from rural district school to university, but did not have a single earned degree from a college or university. His style of administration was dictatorial, and he allowed personal animosities to effect his decisions. The State Board of Education removed Boone in 1899.

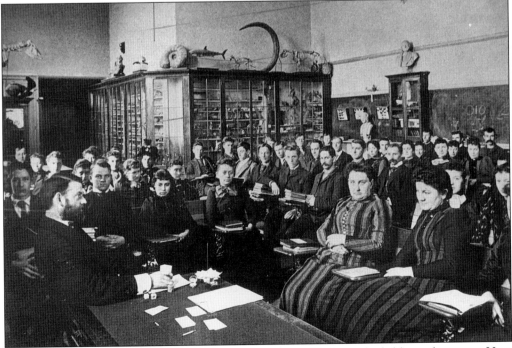

Clothing and hair styles may change, but a classroom will always look like a classroom. Here Professor William Sherzer teaches a class in geology in the Normal School.

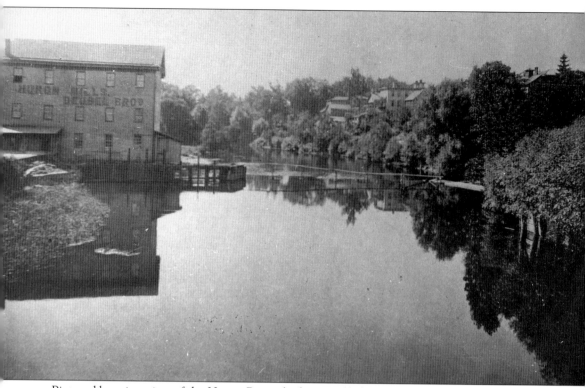

Pictured here is a view of the Huron River, looking south from the Michigan Avenue Bridge in 1893. The building to the left is the Huron Mills, owned by the Deubel brothers. The mill was destroyed by fire in 1915.

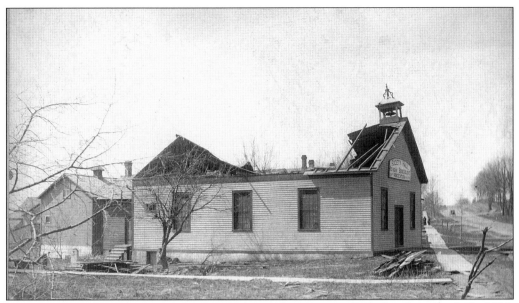

The city of Ypsilanti was struck by a tornado on the evening of Wednesday, April 12, 1893. The tornado swept through the business district at a time when the street was filled with people. There were no fatalities or even serious injuries, but the tornado carried off the roof of Good Samaritan Hall, just as the sexton was about to ring the bell. His surprise can be imagined.

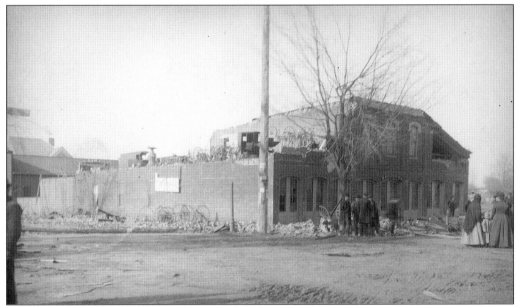

The Curtes Carriage factory, on the southwest corner of Michigan and Adams, lost its roof and the east and west walls on the second floor. The loss of the roof and walls left the finished carriages storied there exposed to the heavy rain.

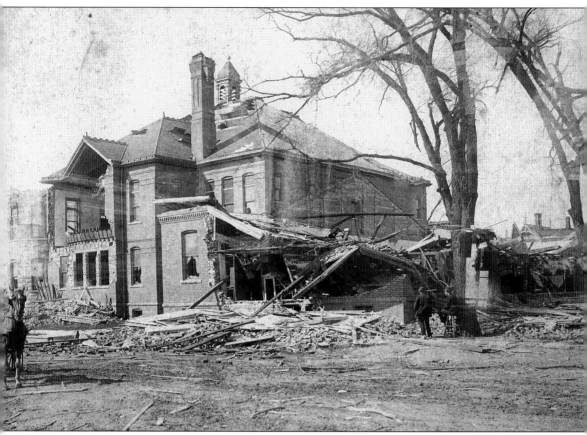

This is a view of the Cleary College Building after the tornado of April 12, 1893. Instructors at the college posted notices promising students that classes would resume on the following Monday. The promise was kept.

The Opera House was almost completely destroyed by the tornado, within a matter of seconds. All that was left standing was the front wall. A new, but far humbler, opera house was later built on the same site.

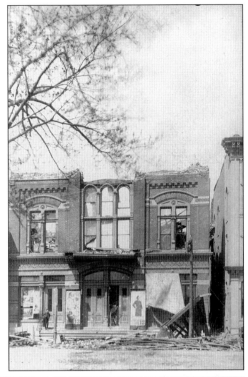

Pictured here is the wreckage of the Opera House as seen from the rear of the building. The tornado dropped the dome-like cupola of the Opera House onto the dining room of the Hawkins House hotel next door. A serving girl was buried under the rubble, but was pulled out unhurt except for some bruises.

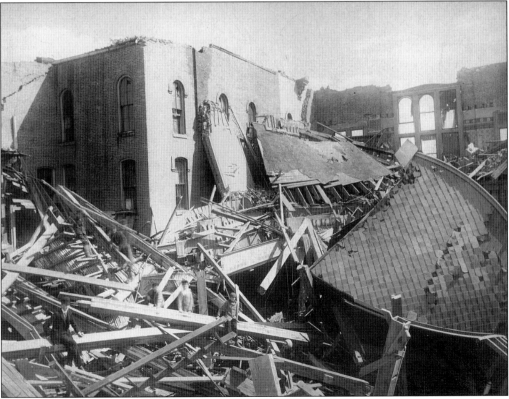

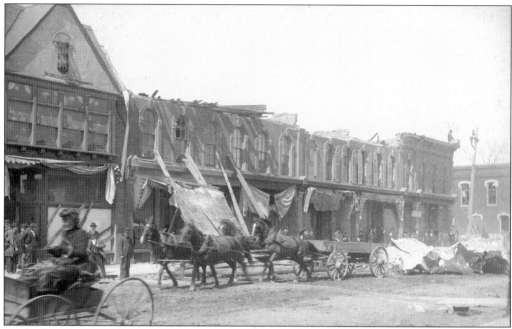

The tornado continued on to the block of buildings facing Huron street. There it rolled up the roofs like paper and tossed the timbers about as if they were feathers. The street was still filled with wreckage when this photograph was taken the next day.

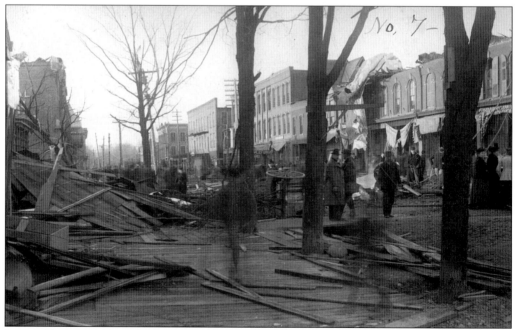

Pictured here is a view of Huron Street from Michigan Avenue, near Pearl Street. Ypsilanti was quite the tourist attraction in the days after the tornado. It seems everyone in Ann Arbor had to come and see the damage. The streets were so crowded that it was almost impossible to get from one place to another. Never before had so many people come to visit the city in so short a time.

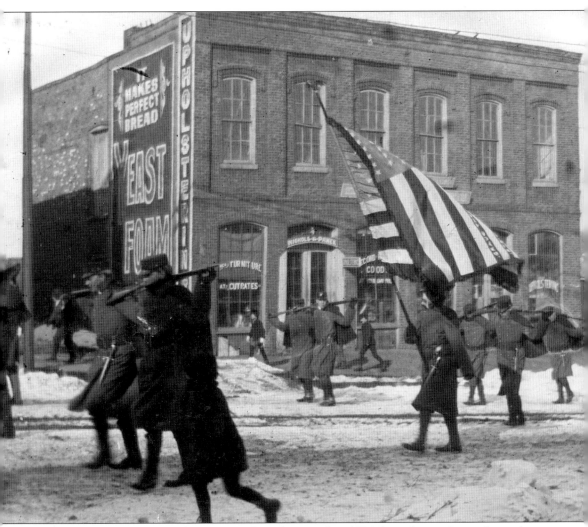

From the earliest years to the present day, the people of Ypsilanti have always favored a hometown parade. Here, the Ypsilanti Light Guard marches past Nichols & Panek Furniture at 2–4 Congress Street, now Michigan Avenue, in about 1894.

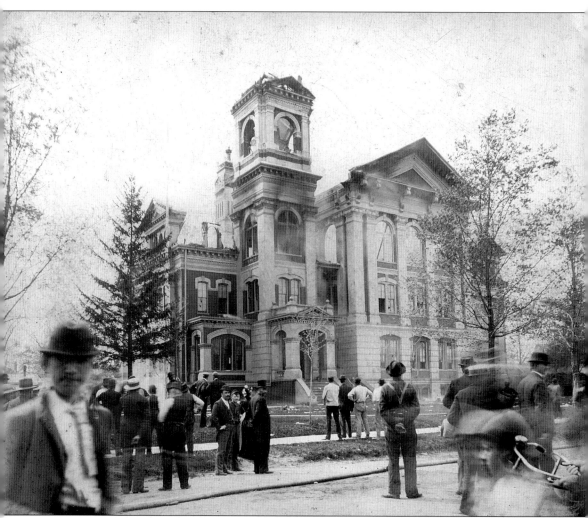

The Ypsilanti Union Seminary Building burned for the third time on Thursday, May 3, 1894. Students had just taken their seats and settled in for an afternoon of study when a crash was heard from the third-floor chapel. Outside the building, 30-foot flames leapt toward the sky. The building was ordered evacuated, and was soon empty of the six hundred students and teachers. The third floor was completely lost, as was most of the second. The new building was built along the same lines as the old one, but with some modifications. The Seminary was demolished in 1929, in order to make room for the west wing of the new high school. This building is now Cross Street Village.

Lucy Aldrich Osband (1835–1912) holds the distinction of being the founder of two departments at the Normal School. She joined the faculty in 1881 and taught classes in natural science. The Natural Science Department was formally established in 1884, and placed under her charge. She also played a major role in starting what became the Department of Physical Education. It was in large part because of her that the Normal Gymnasium was built.

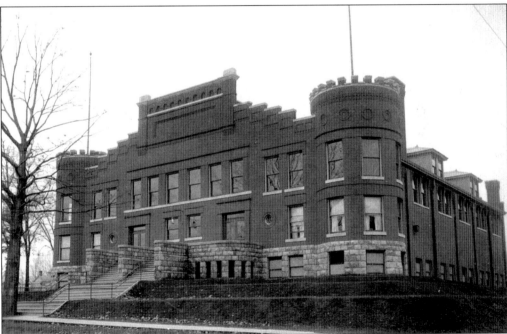

The Normal Gymnasium was dedicated on May 18, 1894. The building was 100 feet square and made of brick with Berea stone trimmings. The architectural style of the building was called "feudal" because of the battlement towers at the front corners. The towers not only accentuated the appearance of the building, but they provided office space for the director and his assistant. A wall rising from the foundation to the roof and running from the front to the rear of the building divided the Normal Gymnasium into two equal departments for men and women.

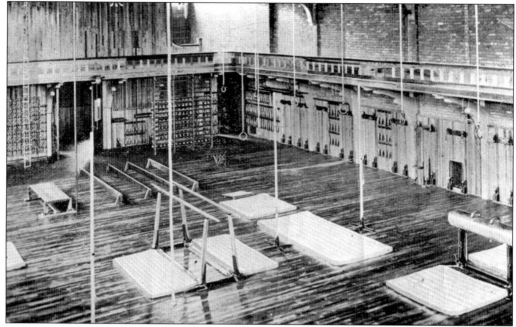

The two main rooms were 48 by 80 feet, and were finished in Georgia pine in the natural color. The men's gym had a running track 9 feet above the gymnasium floor, with a circuit of 250 feet. The gym for the women was to have had a running track, but this was dropped from the plans early in the construction of the building.

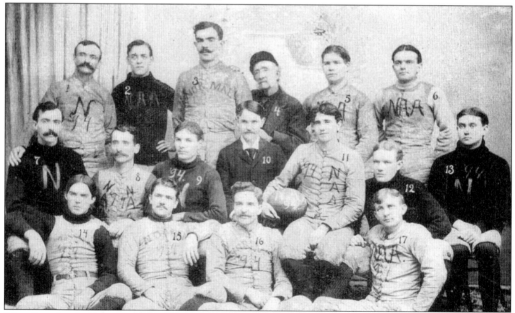

The first football team at the Normal took the field in 1892. Pictured here is the 1894–1895 team that was reported to be the Normal School's best. "The boys are a fine lot of young men," noted *The Aurora*, the school yearbook. "By their gentlemanly conduct and good playing, the interest in foot ball has been raised to a high pitch in the Normal, and the prospects for the great college game are brighter than ever before."

The Reverend Father Frank Kennedy (1866–1922) came to Ypsilanti in 1895. Fr. Kennedy was the first American-born priest at St. John the Baptist Catholic Church. He was unusually brilliant, having passed the state board teacher examinations at the age of 11. He renovated the church, rectory, and school, and was active in the many social programs of the parish and numerous community affairs. When he died, all of the stores in Ypsilanti were closed, and the three separate services held to commemorate him were insufficient in accommodating the crowds. "I doubt," said Bishop Edward Kelly of Grand Rapids, "if any other man in the entire state ever did more to break down religious barriers."

The Soldiers' Monument at Highland Cemetery was dedicated on Memorial Day, May 30, 1895. The monument was erected by the Women's Relief Corp, under the leadership of Florence Babbitt. The monument was made possible by a generous donation from Mary Ann Starkweather.

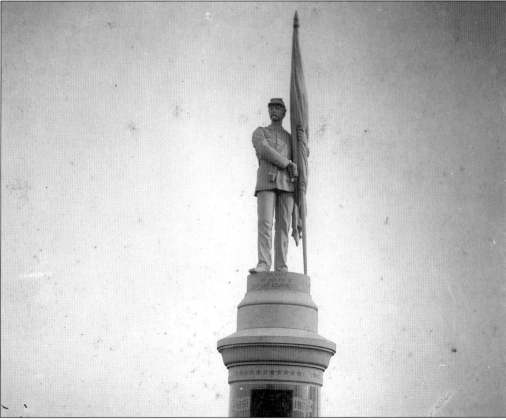

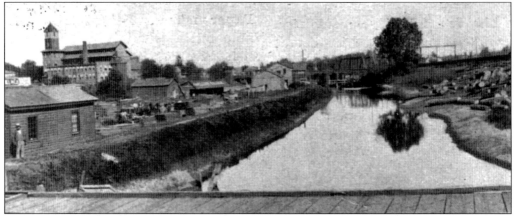

This is the view looking north toward the Forest Avenue Bridge, from above the raceway on Frog Island in 1895. The Underwear Factory can be identified in the left rear of the photograph. The lumber yard of Henry R. Scovill is at left. Scovill moved his yard from Frog Island after the flood of 1904.

The Student Christian Association of the Michigan State Normal School was formed in 1881, and held its meetings in an upstairs room of the Conservatory Building. The room had not previously been needed, so the Association decorated it and used it for their meetings. Then in 1891, as enrollment at the school increased, the Association began working to secure funds for a building of their own. Impressed by their success in gathering over $900, Mary Ann Starkweather gave the Association a gift of $10,000, with the caveat that for its first 99 years the building be used expressly for religious purposes. Starkweather Hall was dedicated on March 26, 1896.

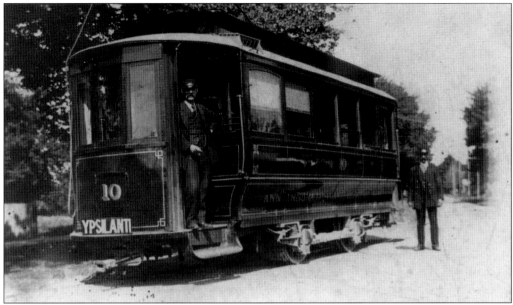

The interurban went electric in 1896, and consequently, operations and receipts greatly improved. Pictured here is the first electric car, which made its first run between Ypsilanti and Ann Arbor on November 26, 1896.

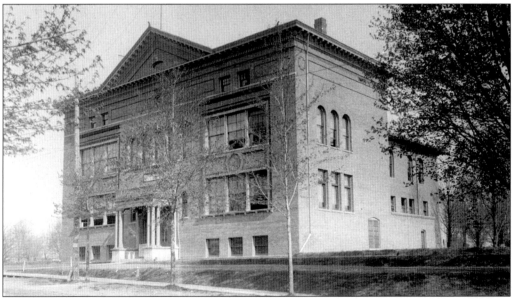

In 1895, the Michigan State Legislature appropriated $25,000 for the erection of a Training School Building on the grounds of the Normal College. This plan ran into a number of problems as, for one thing, the grounds of the college were not large enough for the building. To solve this problem, the city of Ypsilanti paid $8,500 for 3 acres adjacent to the campus. Plans called for the building to be 170 feet in length and 107 feet in depth, with a central portion and two wings. After commencing work on the building, planners discovered that the acquired funds would not cover the cost of the Training School. The plans were reduced, and only the central portion was finished at that time. The building, now called Welch Hall, was dedicated in 1897.

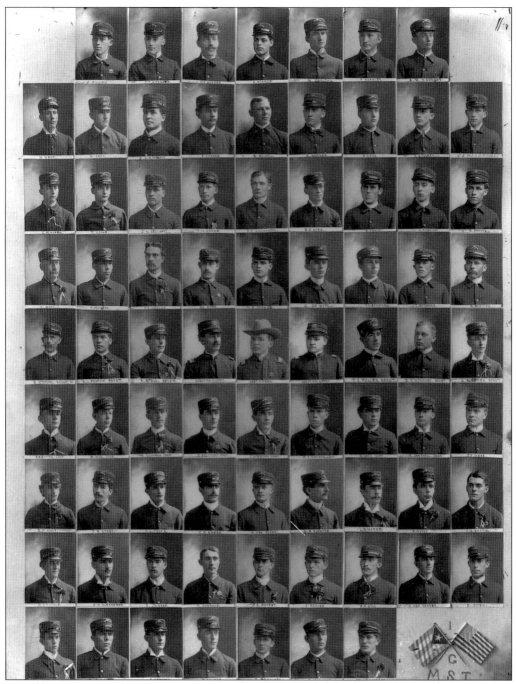

These are the men of the Ypsilanti Light Guard who answered the call of duty in 1898 and served in the Spanish-American War. The men were first sent to Camp Eaton at Island Lake, near Brighton, where on May 9, 1898, they entered the federal service as Company G of the 31st Michigan Regiment. Six days later they were sent to Camp Thomas, in Chickamauga Park, Georgia.

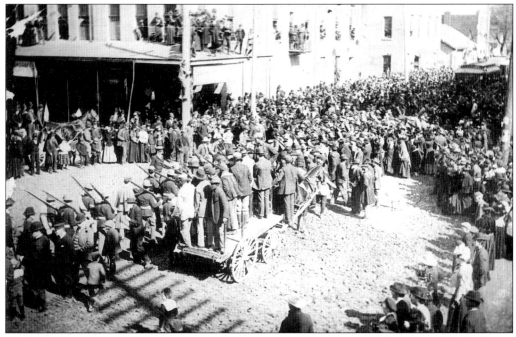

At 9:00 a.m. on Tuesday, April 26, 1898, the 86 men of Company G filed out of Light Guard Hall, marched down the north side of Michigan Avenue and then up the south side. Four thousand people gathered near the corner Michigan and Washington to see them off. The men lined up on Washington Street, where four interurban cars waited to take them. Thousands lined the streets and cheered as the men went off to war.

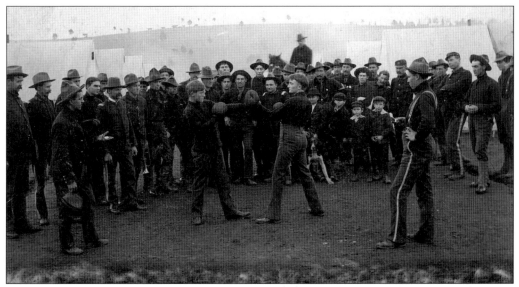

The men spent their time at Camp Thomas training, in drills, playing sports, and getting to know the local girls. Here the men of Company G gather as two soldiers prepare for a boxing match. Conditions at the camp were not as good as they appear in this picture. The water was poor, and sanitation was inadequate. Flies swarmed everywhere. Typhoid became widespread. Soon everyone was doing "the Chickamauga quick step."

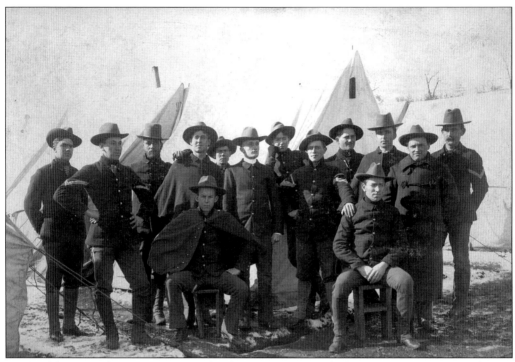

Some of the men of Company G pose for the camera at Camp Thomas. It was at Camp Thomas that Company G suffered its only causality of the war. On the morning of July 27, 1898, Corporal Guy Tuttle died in hospital of "enteric fever."

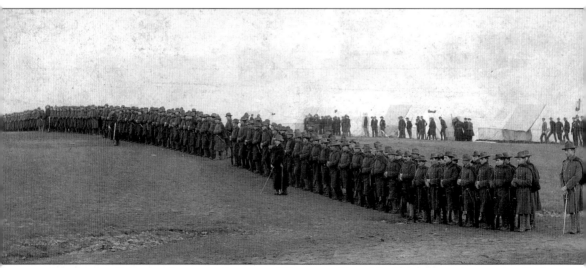

Despite conditions at the camp, the men of Company G could still put on an impressive display on the parade ground. Here Company G stands in formation with the rest of the 31st Michigan Infantry. Upon the insistence of Michigan governor Hazen Pingree, himself a veteran of the Civil War, the Michigan volunteer regiments were numbered 31 through 35, picking up where "the boys of 61" had left off.

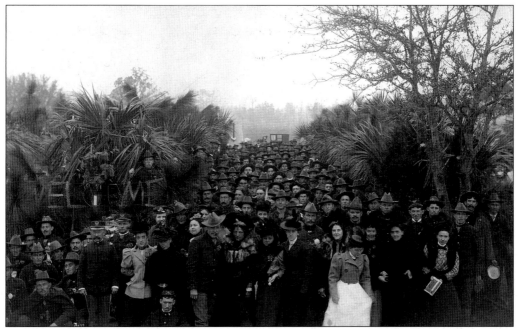

Company G landed at Cienfuegos, Cuba, on February 1, 1899. They had arrived in Cuba after the war was over, and so became part of the Army of Occupation. The men were assigned duty at Amara, about 40 miles inland. There they were able to receive visits from delegations from home, such as the one pictured here.

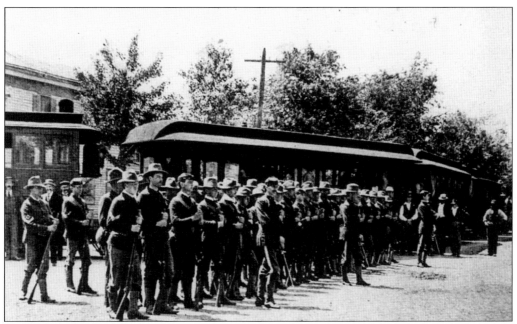

On Friday, May 19, 1899, after 13 months of service, the men of Company G returned home. On arrival the men were treated to a grand celebration that included marching bands and a parade. Then on Monday, May 22, 1899, a banquet was held in their honor in Light Guard Hall. Once the banquet was over, the men began the transition back to their normal lives.

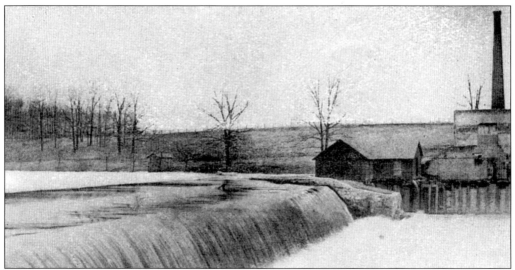

Looking north across the Huron River from the Peninsular Paper Mill, after the fire of 1898 had destroyed the mill on the north side. The tall smokestack (at right) stood for years after the fire, and climbing the metal bars inside it proved to be an irresistible challenge for local boys.

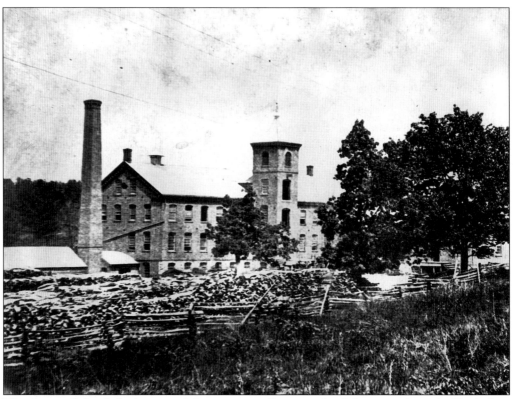

The Cornwell family had operated their paper mill just south of the city, where the Ford plant is now, for many years. They closed the mill in 1898. Times were changing. Technology was bringing innovation and new methods of accomplishing important tasks. Old industries were being replaced by the new.

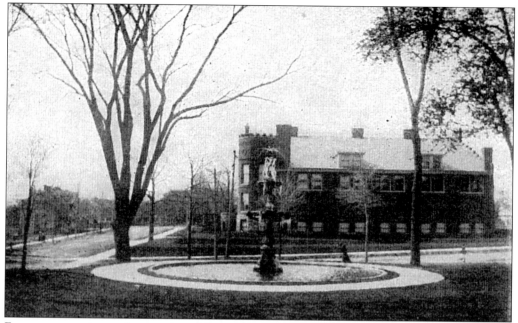

For many years it was the practice of the graduating classes of the Normal to present the school with a class memorial. This was usually a reproduction of some famous work of art, or the portrait of an honored member of the faculty. The most memorable gift was the fountain presented by the class of 1898. The Normal Fountain was a local landmark, overlooking Cross Street from 1898 until its removal in 1961.

The Normal Fountain soon became the most photographed landmark on campus, providing a background as students posed for pictures with family and friends. The fountain was the site of dunkings during the initiation rituals of the student societies. These young ladies sit by the fountain and sigh, because male students at the Normal School were a rarity.

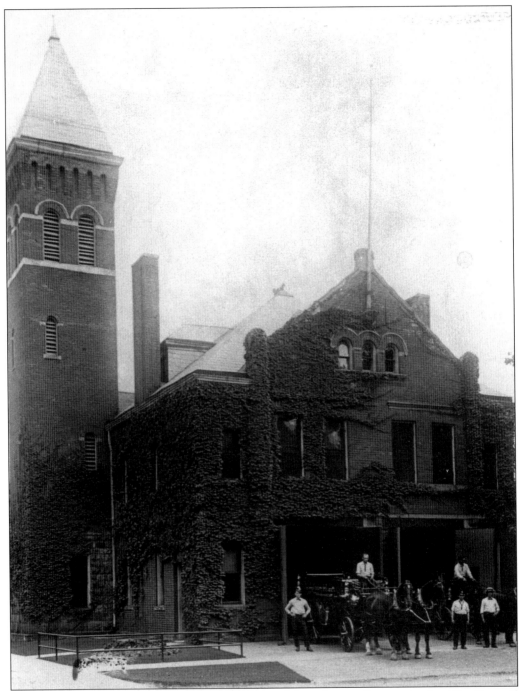

The Ypsilanti City Council voted in 1898 to consolidate the two fire companies. The Council also voted to build centrally-located accommodations for the fire department. Construction of the three-story Victorian Romanesque structure went underway by the end of April, and was completed by August 1, 1890, at a cost of $7,150. The tower was where the hoses were hung to dry after use. There was a bell in the tower, but for many years it was only used to ring in the New Year.

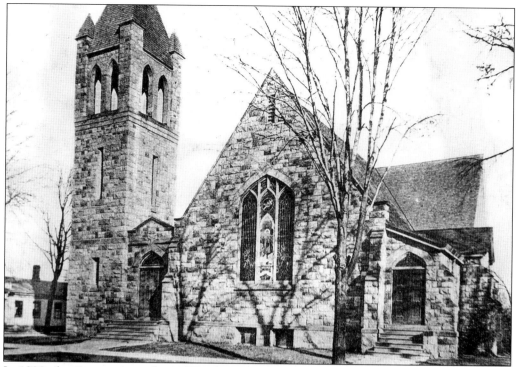

In 1898, the Congregationalists of Ypsilanti decided to enlarge the church to accommodate a growing congregation. The exterior of cut boulders was built around the original structure, and the tower was added. The auditorium was enlarged, three lecture rooms were added, and in the basement space a dining room and kitchen were provided for the Sunday School. The addition was dedicated on June 25, 1899.

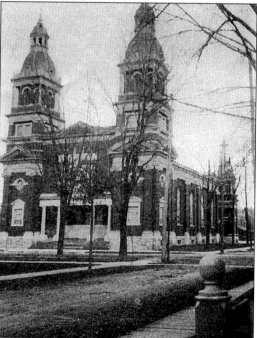

The First Presbyterian Church at Ypsilanti began to take on its current form in 1898, when work to enlarge the building commenced. Detroit architect Julius Hess redesigned the church using the original sanctuary walls, and adding a double entrance with twin towers. The cupola-topped towers are reminiscent of English Baroque churches, but the interior reflects Renaissance architecture. The sanctuary is enhanced by the large rose window, made by Tiffany Company of New York. The formal dedication of the new edifice was held on the afternoon of Sunday, September 24, 1899.

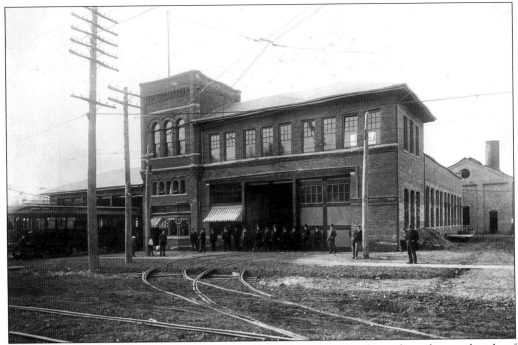

The interurban car barns and power house were built in 1898, and stood on the north side of Michigan Avenue, just east of the Huron River. The building was 120 by 100 feet, and erected at a cost of $15,000. The ground floor was divided into two nearly equal sections, with the car barns on the west side and the repair shop on the east.

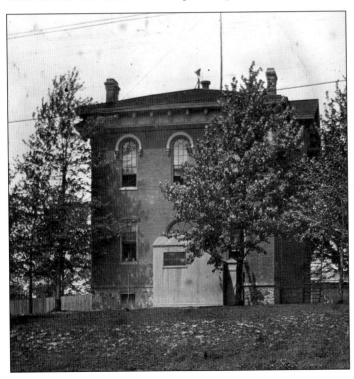

The one-room schoolhouse was giving way to more modern styles when the new Fifth Ward School was built in 1899. The house still stands on the northwest corner of Michigan and Prospect, but its days as a school are long past.

A view of Congress Street, now Michigan Avenue, as it appeared for most of the 1800s. Note the wooden awnings projecting over the sidewalk in front of nearly every store. Nicknamed the "Cow Sheds," many people considered them ugly and called for their removal. The City Council ordered the removal of the awnings in October of 1899, but no action was taken by the property owners.

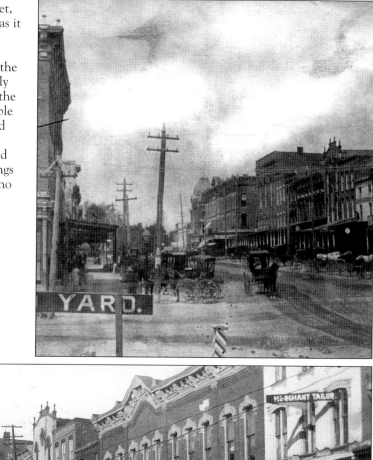

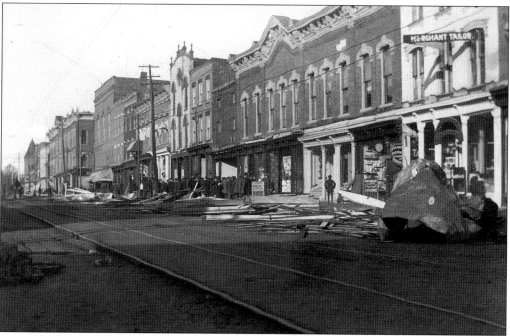

The City Council of Ypsilanti had ordered the removal of the wooden awnings to be carried out within 30 days. The property owners, who wished to keep the awnings, retained an attorney, but took no further action. On Friday, November 3, 1899, the 29th day, men employed by the city started at one end of the street, and pulled down each of the awnings until none were left. The remains of the awnings littered the street the next morning.

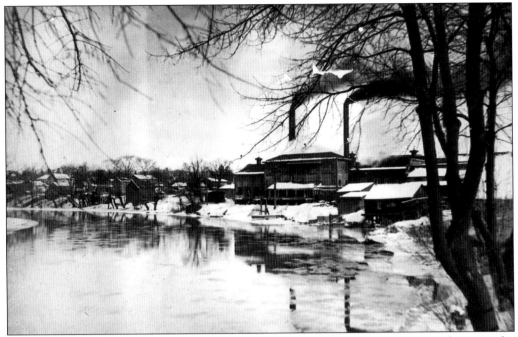

Here the interurban power house is pictured as seen from the Congress Street Bridge, now the Michigan Avenue Bridge, in about 1900. The interurban made its last run in 1929, when it was replaced by the automobile. The buildings were used as a retail space for years afterward, and were demolished in the early 1970s.

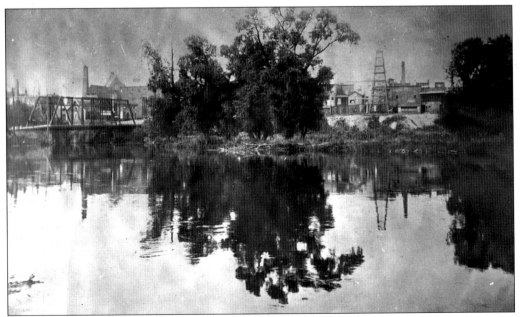

This picture provides a look west from the interurban power house, in about 1900. At left, once again, is the Congress Street Bridge. The drilling rig to the right stands behind the Sanitarium on Huron Street. The rig provided the Sanitarium with mineral water, which was used to treat nervous disorders. As it turned out, mineral water had no medical benefits whatsoever.

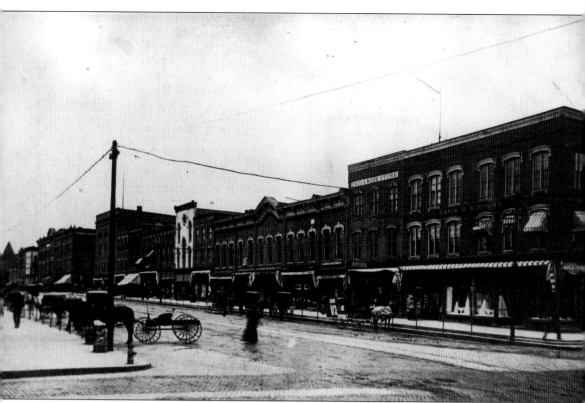

Here is another glimpse from the southeast corner of Michigan and Huron, where City Hall is today, in about 1900. The buildings on the street appear much the same today, but note that the streets were then paved with brick.

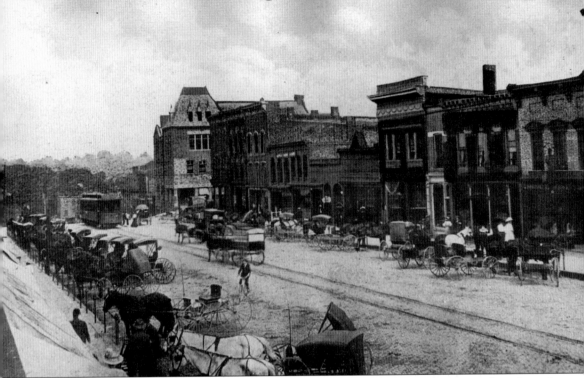

This image depicts a busy day in Ypsilanti in 1900. One century was about to end, and another was about to begin. Ypsilanti had changed since the founding of Woodruff's Grove in 1823, and would change even more over the years of the next century. The next 100 years would change Ypsilanti with two World Wars, the Great Depression, and the development of the automobile, but that is a story for another time.